Quintessence

The Alternative Spaces
Residency Program

Number 2

Quintessence

The City Beautiful Council
of Dayton, Ohio

The Wright State University
Department of Art

Project Director
Paul R. Wick
Administrator
City Beautiful Council

QUINTESSENCE is the
catalogue of The Alternative
Spaces Residency Program
administered by the City
Beautiful Council and the
Wright State University
Department of Art, Dayton,
Ohio.

Funding provided by the Ohio
Arts Council and the National
Endowment for the Arts, a
Federal agency, is gratefully
acknowledged.

QUINTESSENCE
Copyright © 1979
City Beautiful Council
Dayton, Ohio
All Rights Reserved

Library of Congress Catalogue
Card Number 79-54977
ISBN 0-9602550-0-1

Editor: Susan Zurcher
Assistant to the Administrator
City Beautiful Council

Design: Bob Bingenheimer
Bingenheimer Design
Yellow Springs, Ohio

Photographs: Susan Zurcher
except paired images on
pages 19 through 29; page 50
bottom by Pat Tehan; pages
51 bottom and 70 by Walt
Kleine; pages 57 and 63
through 66 furnished by the
artist.

Printed on Black and White
Enamel Dull with Black and
White Enamel Gloss Cover
contributed in part by Mead
Paper Group, Dayton, Ohio,
with Strathmore Rhodo-
dendron inserts. Printed by
Carpenter Lithographing
Company, Incorporated,
Springfield, Ohio.

Display and text set in Avant
Garde Book on Mergenthaler
VIP.

Printed in the United States of
America.

Mayor James H. McGee, Commissioners Patricia M. Roach, Richard A. Zimmer, Richard Clay Dixon, Abner J. Orick, City Manager Earl E. Sterzer, Planning Director John M. Becher, members, staff and friends of the Dayton City Beautiful Council, faculty and students of the Wright State University Department of Art, and the People of Dayton.

6-29-81 - pub - $6.00

Acknowledgements

Special thanks to Ray Bushbaum, Stephen Ward, Suzanne Domine, Darrell Farley, Sharon Schrodi, Tim and Sharon Patterson, Bob Heilbrunn of Dayton Fabricated Steel, Morgan Howard of Blosser Color Lab, Gail Landy of Dayton and Montgomery County Public Library, Jim Davis, Charles Requarth, Fred Bartenstein, Congressman Tony Hall, Ed Levine, Pat Carver, Tom Macaulay, David Leach, Steve Chappell, Greg White, Stuart Delk, Doug Hollis, Jack Davis and Erv Nusbaum of Wright State University Photo Services, Dayton Daily News Photo Library, Montgomery County Fairgrounds, Catholic Social Services, National Cash Register, Platt Iron Works, City of Dayton's Departments of Police and Fire and Divisions of Park Maintenance, Traffic Systems, Engineering and Street Maintenance and Mead Corporation, Dayton, Ohio.

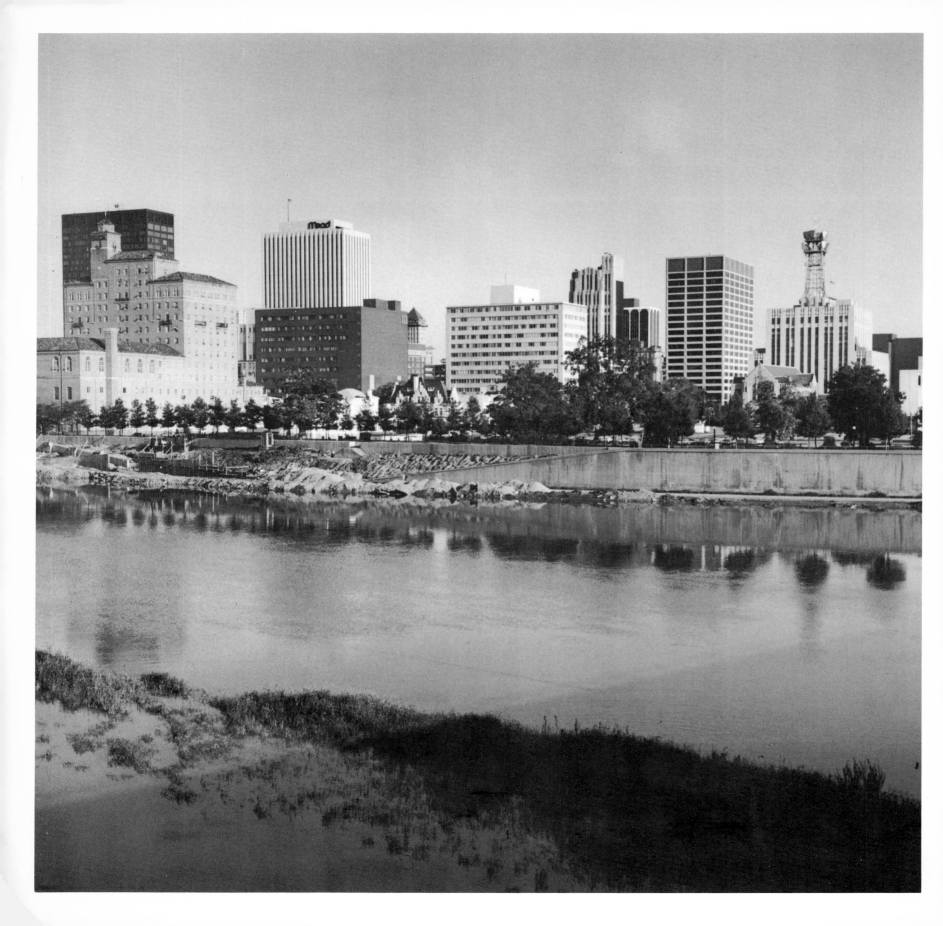

Contents

Dayton, along the Great
Miami River

Introduction

Creative Arts Center
Wright State University

It is a pleasure to present, on behalf of the City of Dayton, Ohio and Wright State University, the second volume of QUINTESSENCE which documents the work undertaken during our 1978-79 Alternative Spaces Residency Program. This catalogue allows us to share with a wider audience the adventures in contemporary art which we have had the pleasure of sponsoring. Reaction to our first catalogue was most gratifying. We trust that we learned something during the past year and hope this volume will be received as enthusiastically as it is offered.

For those readers who are unfamiliar with our program, some background information would seem in order. The participating artists were invited to roam the city in search of a project site as opposed to being assigned a site and asked to work with it. This may have been the most difficult task the artists faced, as the variety of spaces available is almost unlimited. The artists then conceived their projects and did most of their work on site. We are not aware of another ongoing program in which an artist is asked to assume so much responsibility for site selection.

Joint sponsorship of this program by the Dayton City Beautiful Council and the Wright State University Department of Art began in 1977. Since that time businesses, labor unions and interested citizens have joined students and city staff in working with visiting artists. As our 1979-80 program is getting under way, substantial involvement by the Dayton Art Institute and regional colleges and universities is emerging. This remarkable support system which brings government, academia, business, labor, private institutions and individual citizens together may be viewed as an extension of the creative process which allows an artist's ideas to be realized.

Of course, the heart and soul of this program is the work portrayed on the following pages. Every attempt has been made to capture the dynamics of the process through which the projects were created, as well as the completed pieces. An exception is Michael Singer's section of the catalogue. He prefers that his work be viewed only in its final form.

Each of the artists was asked to submit a narrative to accompany the documentation of their work. The narratives serve to convey something of the artists's experience with the program as well as insights about their work. An exception here is Jackie Ferrara's section. She chose to submit drawings without a text.

It had been our intention to offer, as part of this catalogue, a critical essay which would address the artist's work individually and comparatively. Due to an unfortunate combination of circumstances, there is no such essay. If we have any genuine apologies about this offering, it is for the absence of such a piece of critical writing.

Despite this writer's oft repeated self-admonition that bureaucrats should not try to be critics, a few issues about the nature of a program such as this one ought to be raised.

Most contemporary art grows out of a studio environment. It is an interior exploration: personal, self-expressive and, to some extent, predicated upon the notion of rebellion. Probing the nature of art itself, contemporary artists are questioning traditional values. A community, on the other hand, maintains a different perspective and expects a reflection of the world and its values in art.

The Dayton projects provide an important opportunity for interaction between the artist and the community. The artist's view of artistic activity and concomitant rights must be reconciled with the rights of society as interpreted by a community. Where art is involved with asking itself about itself and probing the boundaries which separate it from or link it to other activities, there is a great potential for both conflict and growth. Art may confront or offend due to the nature of what is being questioned. Where deeply held cultural values are being questioned, art can become an irritant. Art can also illuminate.

The Dayton projects are an attempt to bridge the gap between the private sensibilities of the artist and the public consciousness. The artist is given an opportunity to work in a context which is simply not available in a museum or gallery. The artist is further challenged to assume some responsibility to the community in which he or she is working.

Artists need opportunities to break through the social, physical, economic and often hidden aesthetic barriers of the major art centers such as New York, Chicago and Los Angeles. They must try new ideas, obtain the reaction of a more diverse public than they normally encounter and have access to a laboratory where notions about art, aesthetic taste and spectator behavior can be tested. Ideally, the results of these tests will generate additional questions and the investigation of new aesthetic ideas.

The projects also provide an opportunity for the public to experience art in the familiar context of the community and beyond the often mythic setting of the formal art institution. These encounters may open up new perceptions about familiar places or forgotten spaces and present the public with new dimensions of experience.

Out of these interactions between the private sensibilities of the artist and the public consciousness, a new understanding may emerge which the artist can take back to the studio. The Dayton program thus provides the possibility for a genuine reciprocity between art and the public's understanding of art, a give and take which can establish the basis for new endeavors precisely because of the renewal of a dialogue between art and the public which has been dormant for so many years.

There is evidence of a renewal of this dialogue in the constituency which has developed around the program since its inception. The breadth of involvement delineated in this catalogue's acknowledgements as well as the response of the community tends to suggest this.

Attendance at lectures and symposia which have been held to explore these issues in greater detail is a further testimonial to the renewal of a dialogue. For these and other reasons, we are excited about the future possibilities of this kind of program.

We were honored to have had a visit from America's foremost arts advocate, Joan Mondale, during Mary Miss' project. Mrs. Mondale's presence helped to focus additional public attention on our experiments in art for public places.

A particularly interesting question is what to call the work produced within the elastic parameters of this sort of program. The term "public art" has been in common use for some time now. It seems that a number of people have serious philosophical and semantic difficulties with this label, however. Artist Scott Burton has suggested "civic art" as a description which captures a little more of the essence of the phenomenon. Happily, we toss this question to the critics and linguists for discussion and resolution.

Special thanks must be extended to J. T. (Tim) Patterson, Jr., President of the Dayton City Beautiful Council. His tireless efforts have helped to assure the success of this program. Sufficient praise cannot be lavished upon Mike Alexinas and the personnel of the city's Division of Park Maintenance. The parks team is rapidly establishing itself as one of the premier art building forces in America. A debt of gratitude is owed to Mayor James H. McGee and Dayton's City Commissioners for providing us with the freedom to do what we do.

The advice and counsel of Ed Levine is warmly and gratefully acknowledged. Finally, our thanks and best wishes to Jackie Ferrara, Richard Fleischner, Doug Hollis, Mary Miss and Michael Singer who made the past year more interesting and enjoyable for all of us.

Paul R. Wick
Administrator
City Beautiful Council

It is art that *makes* life, makes interest, makes importance, for our consideration and application of these things, and I know of no substitute whatever for the force and beauty of its process.

Henry James
Letter to H.G. Wells, 1915

Jackie Ferrara

Richard Fleischner

Doug Hollis

Fall 1978

Jackie Ferrara

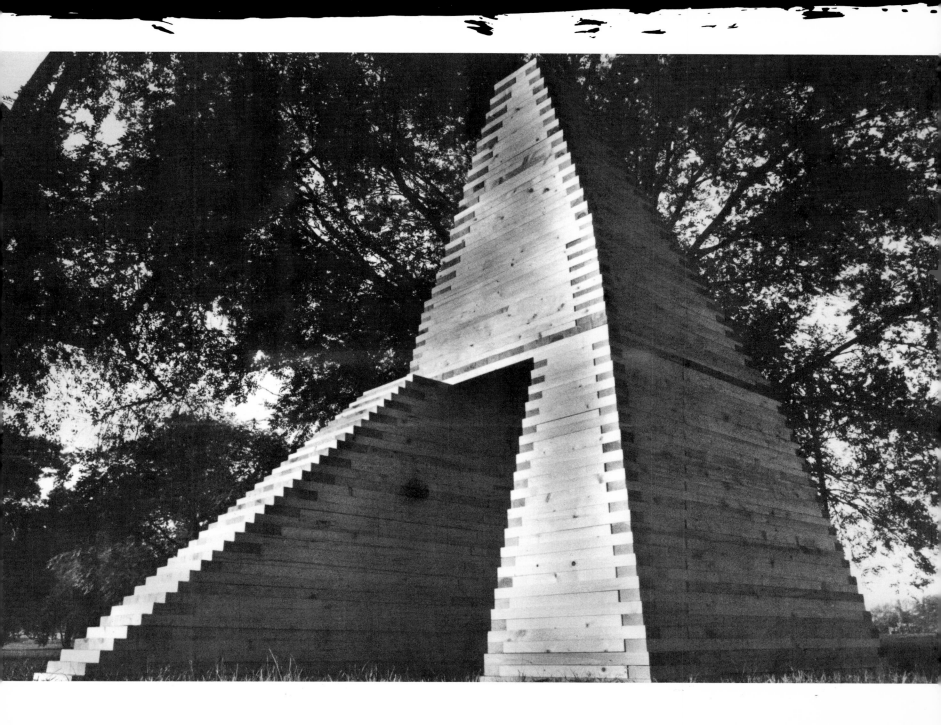

DAYTON ARCH, Riverbend Park

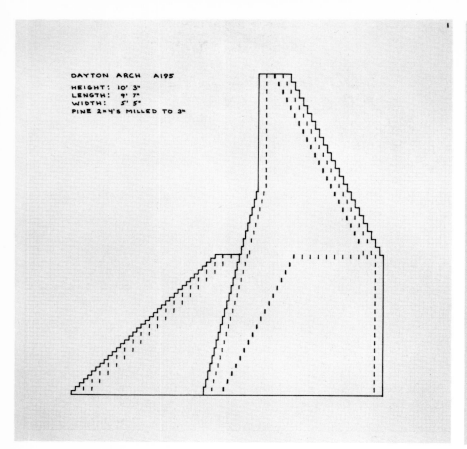

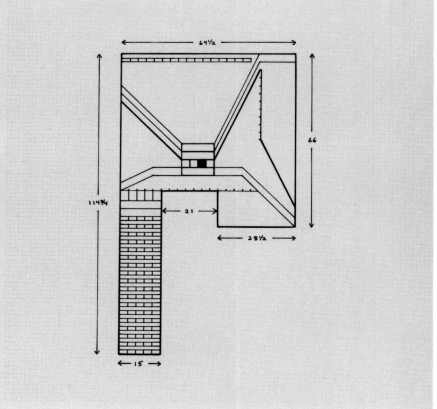

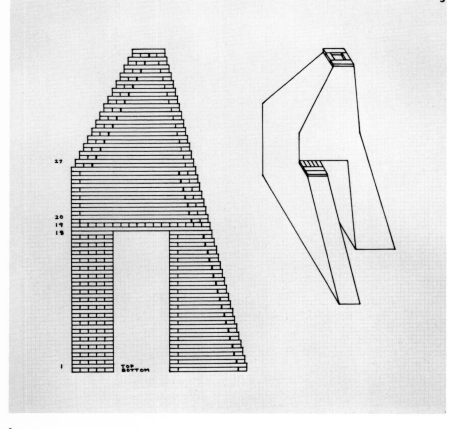

DAYTON ARCH A195

HEIGHT: 10' 3"
LENGTH: 9' 7"
WIDTH: 5' 5"
PINE 2"×4'S MILLED TO 3"

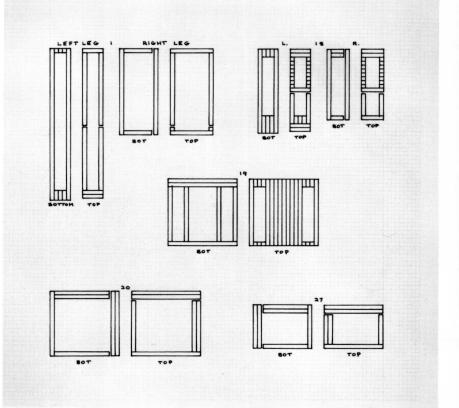

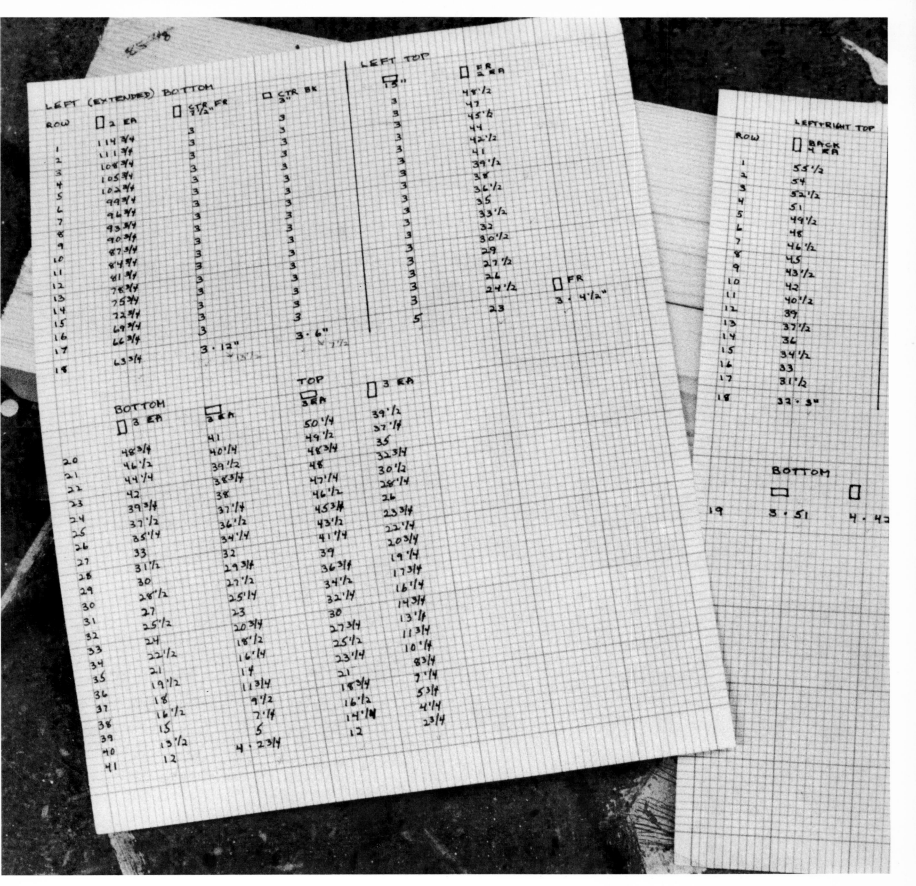

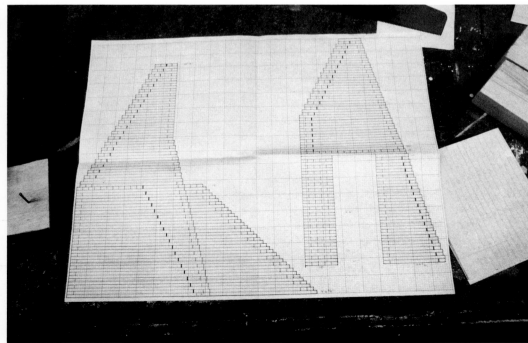

4

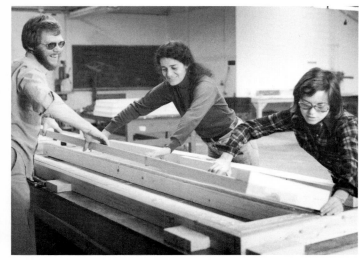

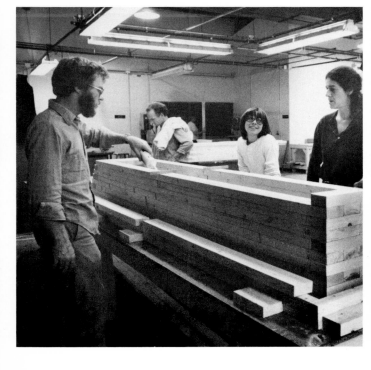

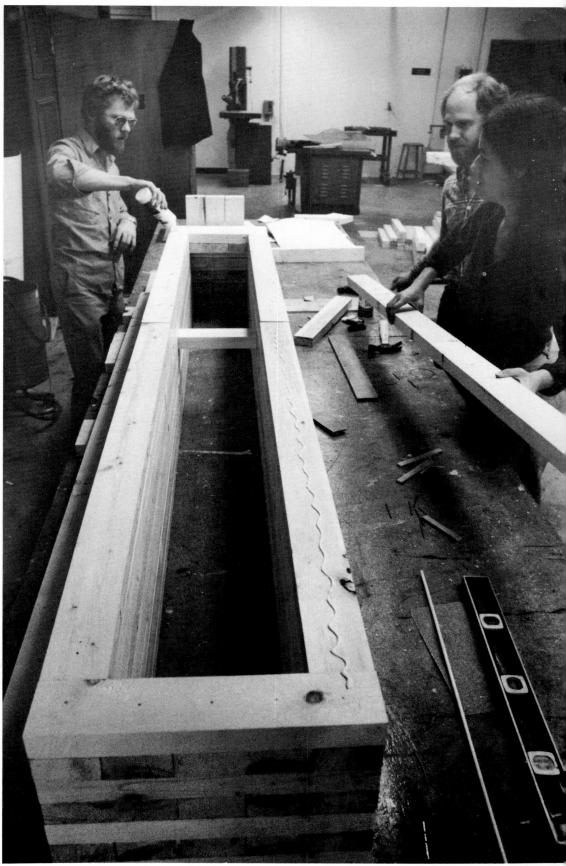

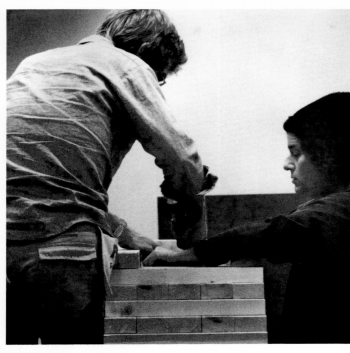

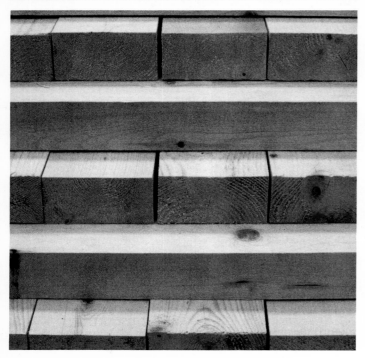

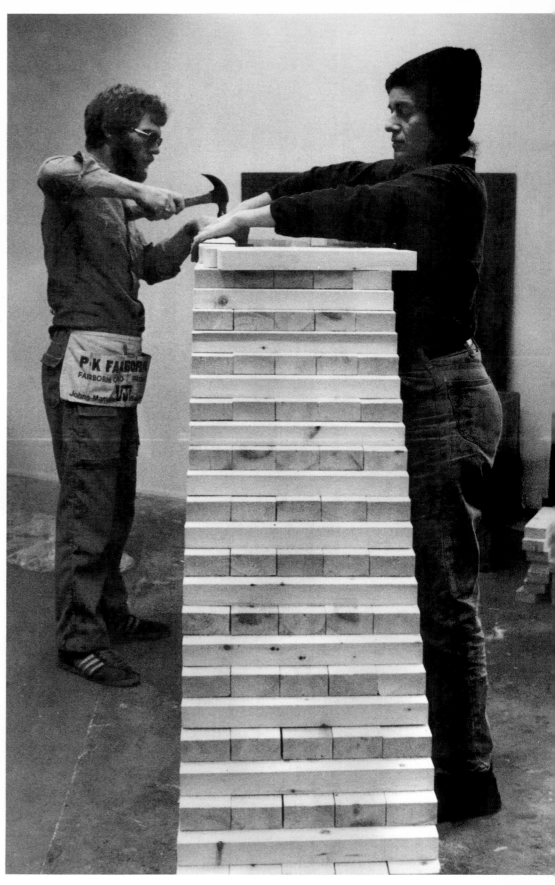

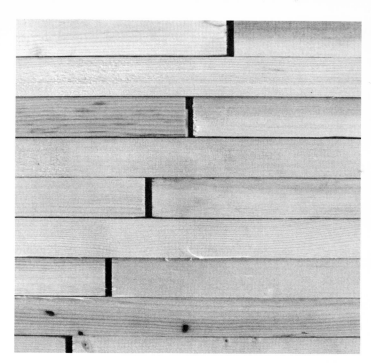
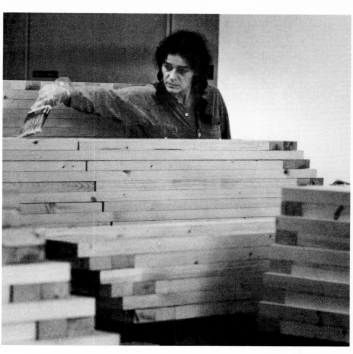
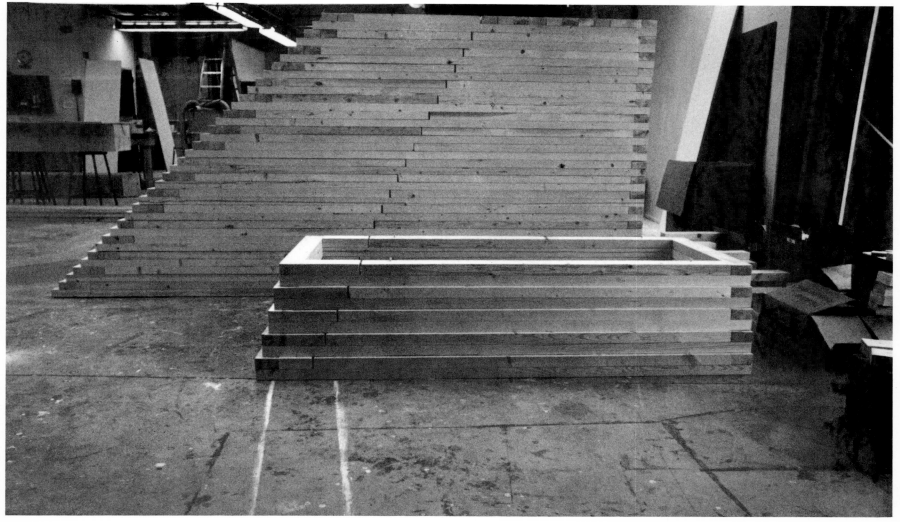

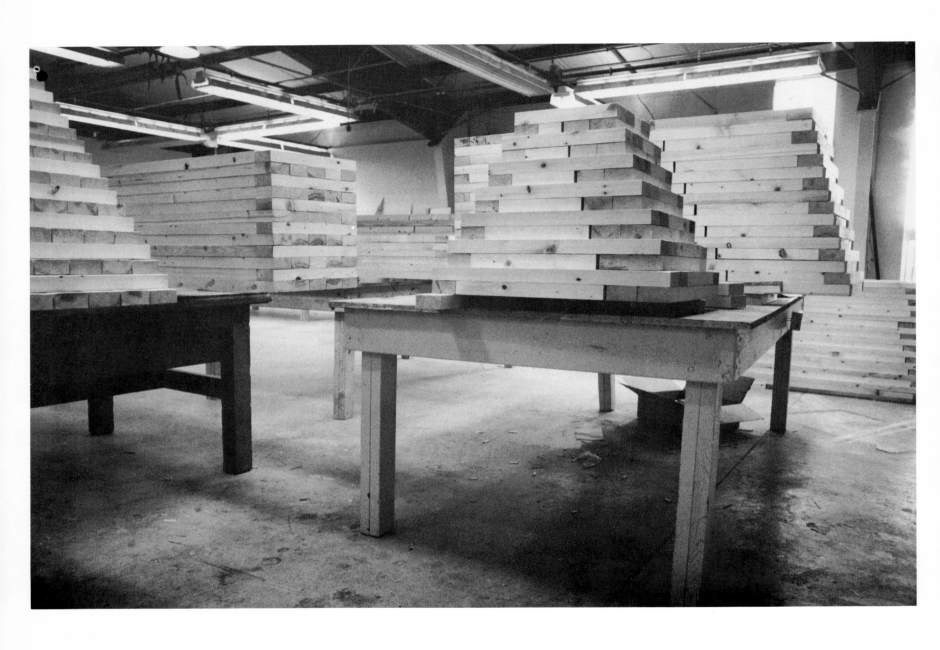

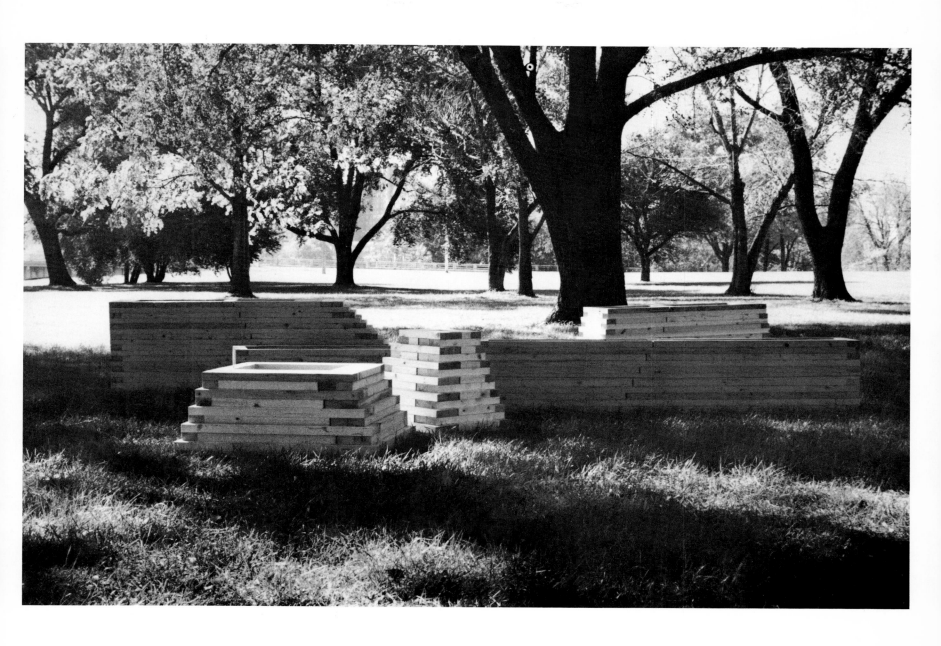

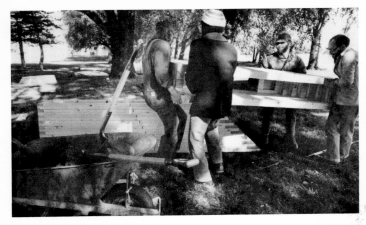

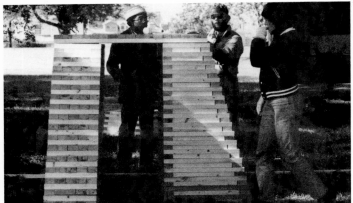

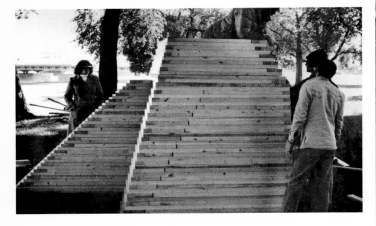

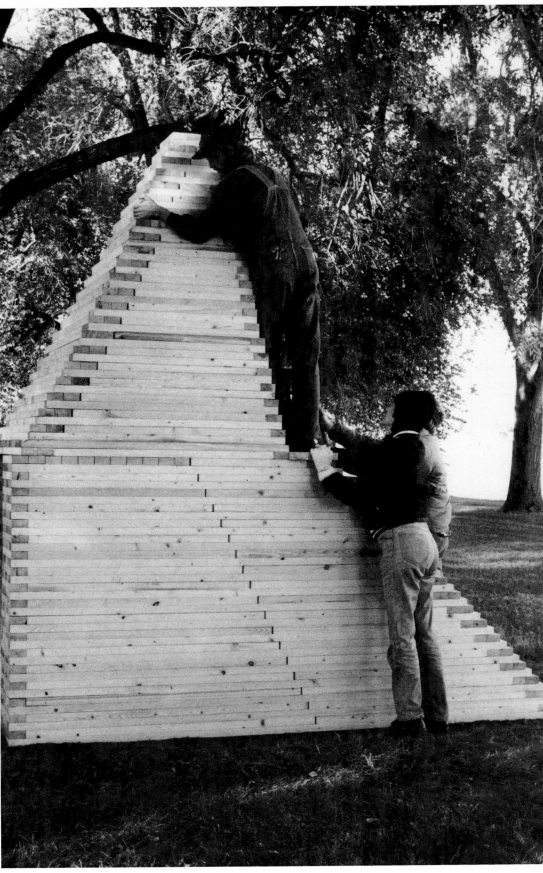

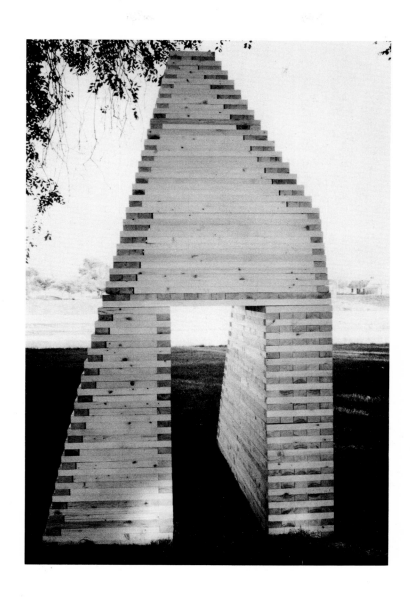

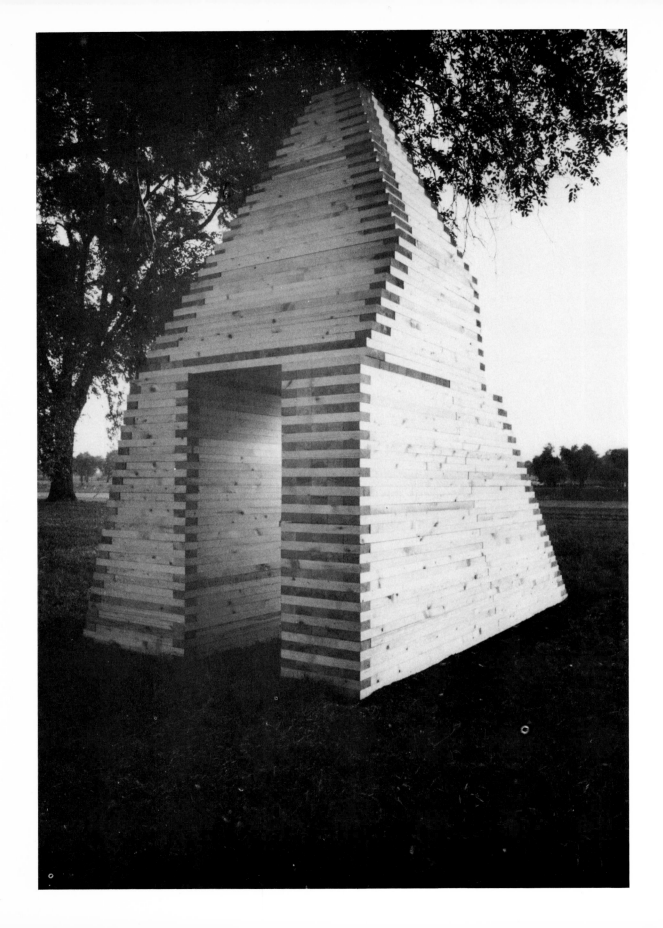

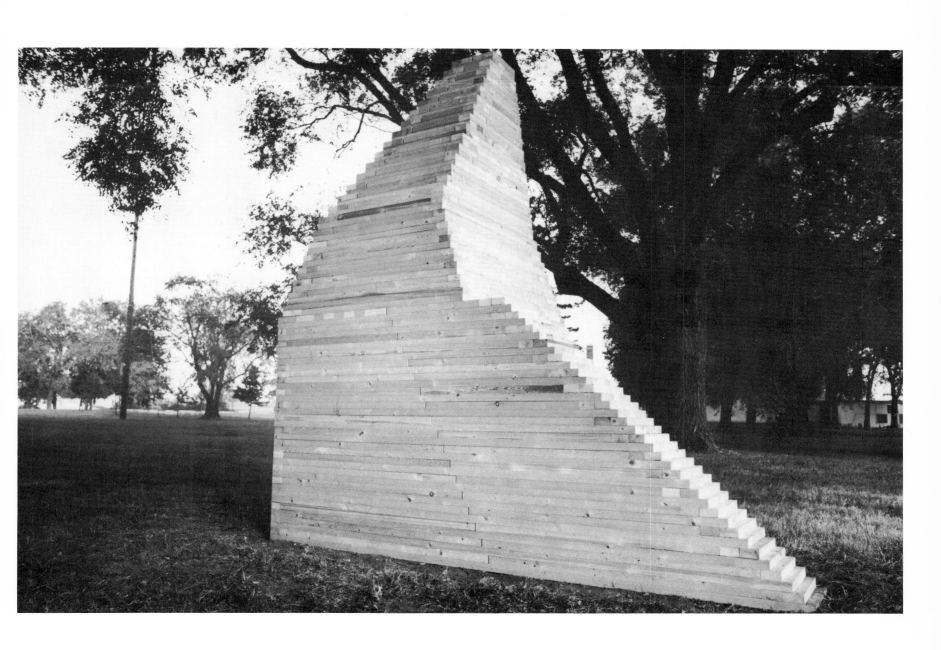

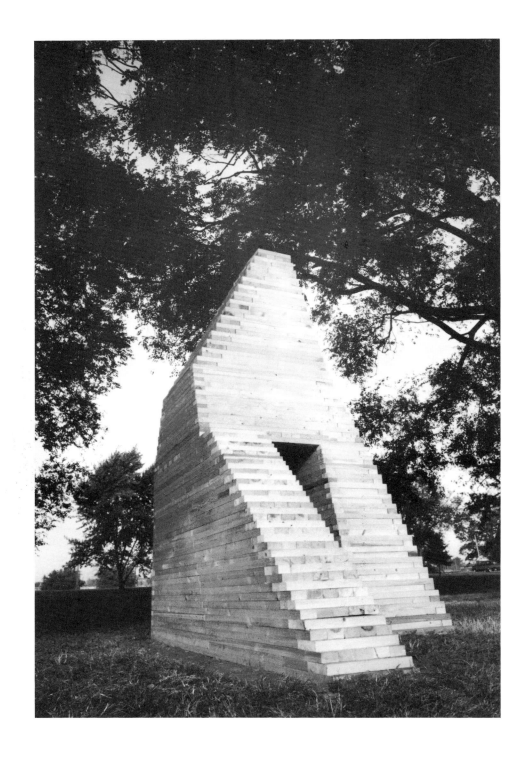

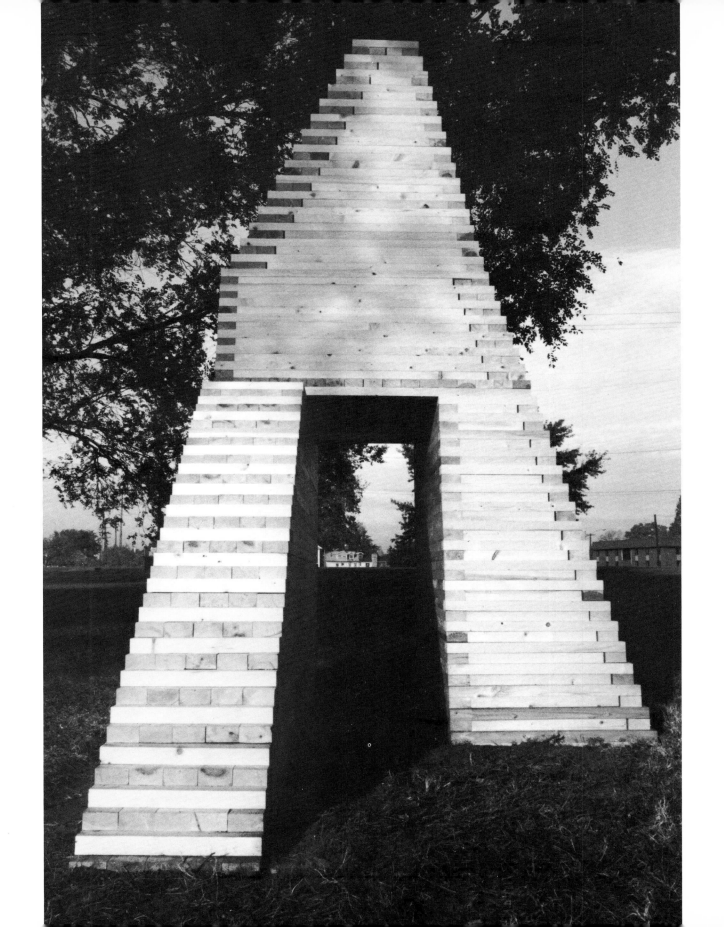

Assisted by Cyrus Gibson

Richard Fleischner

The Dayton project evolved from my wanting to work with more than the physical attitude of a particular space. In most of my previous work I have had intimate contact with a specific site but very little awareness of the larger community in which the site exists. This project involved learning about Dayton, past and present.

I worked in the library with an assistant, spoke with people who knew elements of Dayton's history and saw as much as I could by walking and driving around. I was concerned with time and the changes it brings, those which can be seen and visually represented by photographs juxtaposed at various sites.

Each set of photographs was taken from the same spot — or as close to it as possible — at two different times. The time between these pairs ranges from less than a minute to more than seventy years. Generally, pairs of images were chosen by selecting old photographs, returning with them to the places from which they had been taken and rephotographing the spaces as they appear today. For instance, the pair of photographs at Jefferson Street and Patterson Boulevard shows the space with and without the canal. In the case of the Callahan Building at Third and Main Streets, I found the site and searched backward to find an earlier photographic record of that corner. I visited places such as NCR and paired images which reflected the consequences of economic change in an emotional way.

All photo pairs were fixed in stands and placed at the spot from which the photographs were taken.

Richard Fleischner

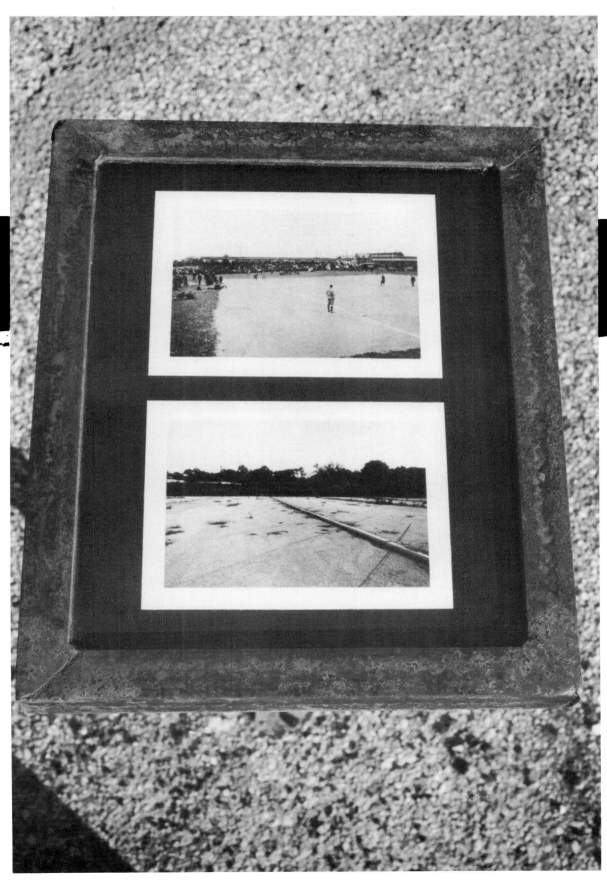

National Cash Register,
Parking Lot A

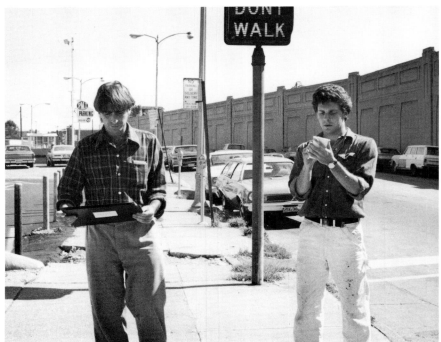

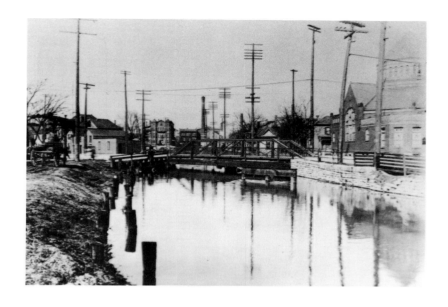

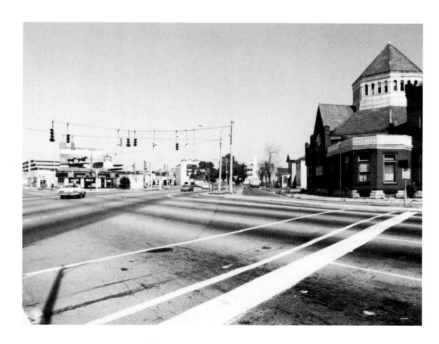

Jefferson Street at Patterson
Boulevard

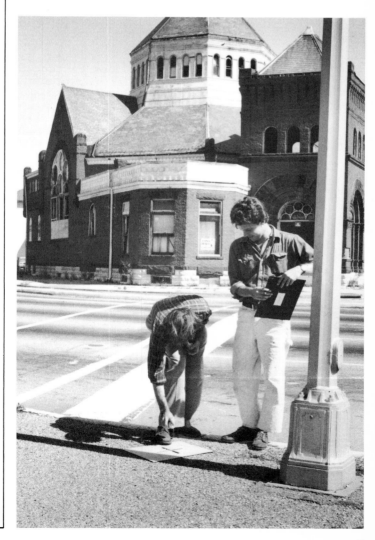

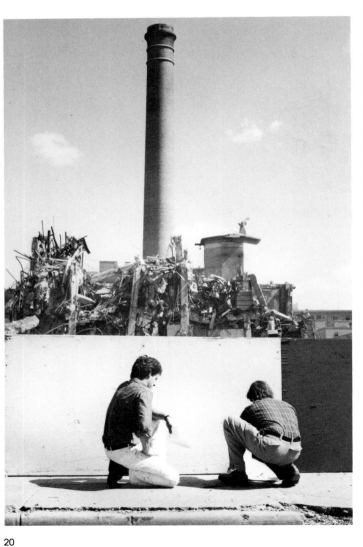

National Cash Register,
Building 10,
South Main Street near Stewart

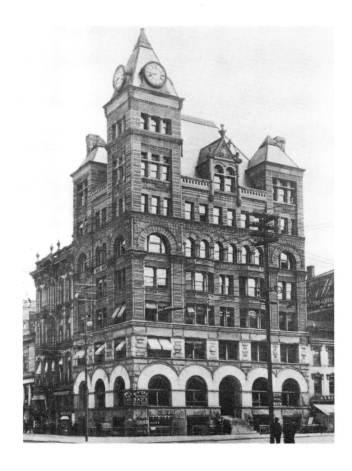

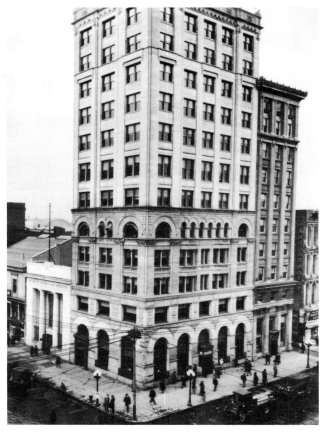

Callahan Building, Third and
Main Streets

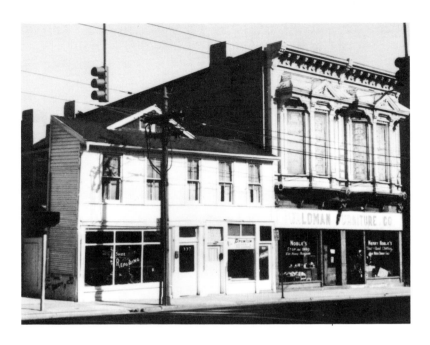

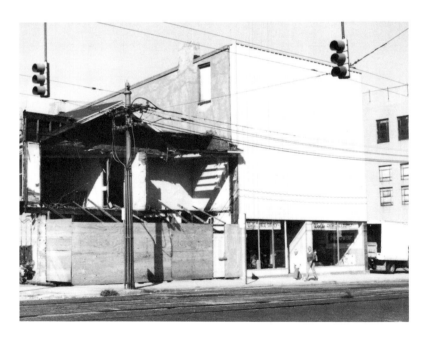

Fifth Street at Brown

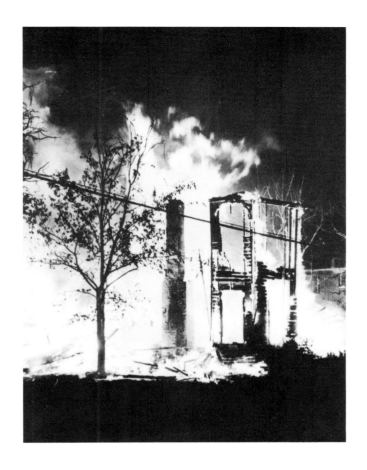
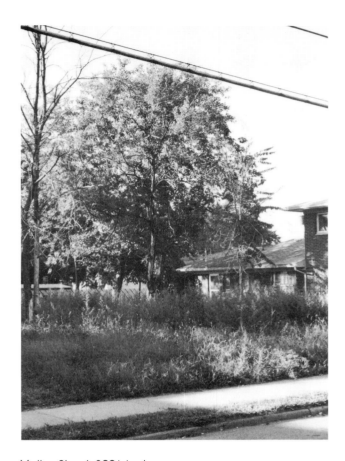

Valley Street, 800 block

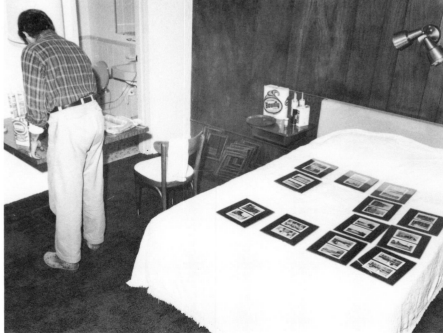

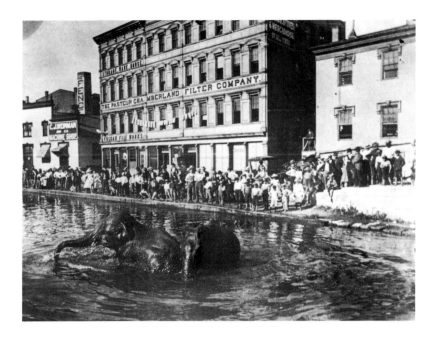

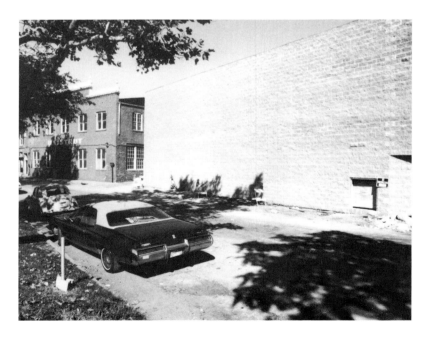

Patterson Boulevard East Drive
at Third

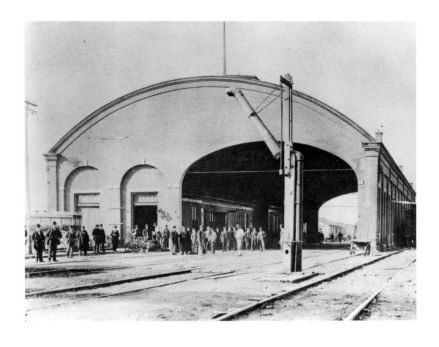

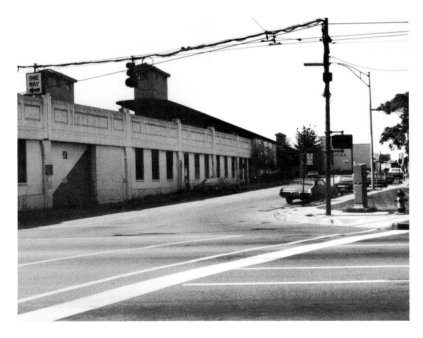

Ludlow Street at Sixth,
northeast corner

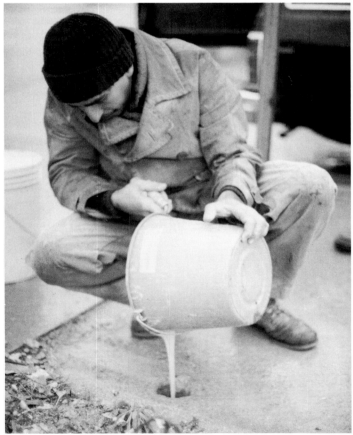

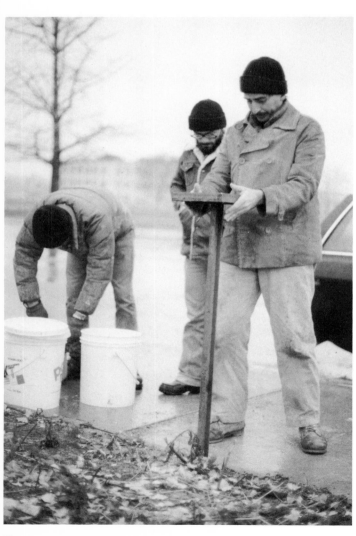

Caldwell Street near South Main

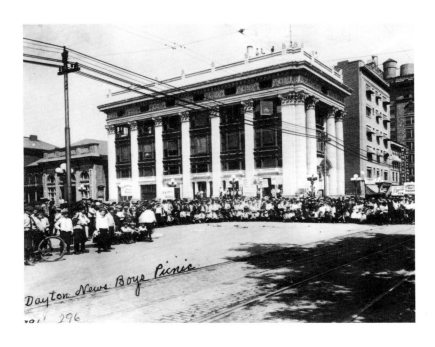

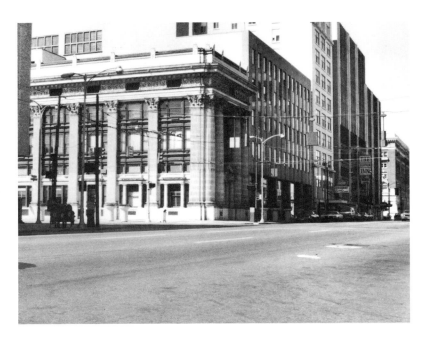

Ludlow Street at Fourth

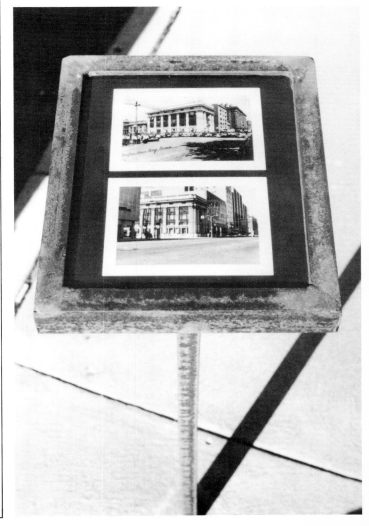

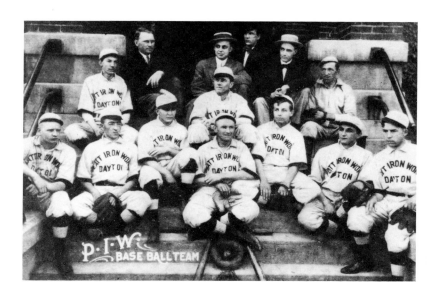

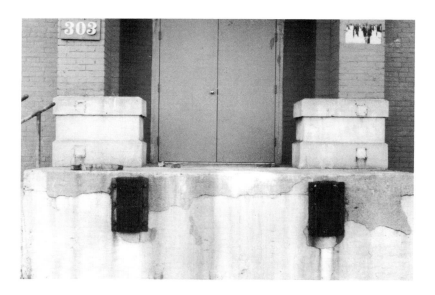

Platt Iron Works, 303 North
Keowee Street

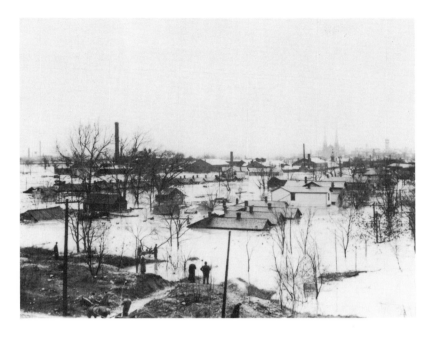

Montgomery County
Fairgrounds overlooking
Apple Street

Additional Sites

Second Street between Main
and Ludlow

Ludlow Street at Sixth,
southeast corner

Bomberger Recreation Center
steps

Keowee Bridge

North Main Street at
Monument

Orth Avenue at Riverview

South Main Street between
Fifth and Sixth

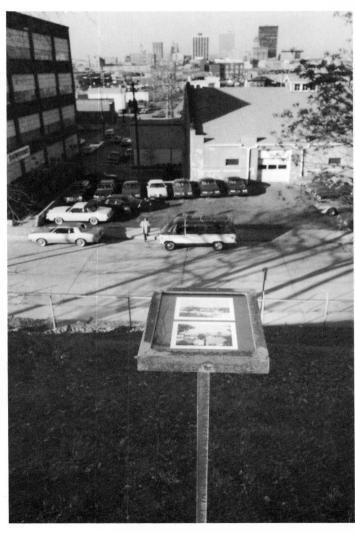

MIRAGE, Deeds Point

Mirage
Telltales: Conversations with
the Wind

—for the Shawnee people

HULL'S RENDEZVOUS

Here, where the Shawnees
were defeated by Clark's
1782 expedition, Dayton
was founded, in 1796.
Hull's army and other War
of 1812 troops were mobil-
ized at this point.

conversations I had with that place.

When I returned to Dayton two weeks after completing the construction on Deeds Point, I stayed with Tim Patterson. One evening we discussed the work I'd done and my involvement with natural phenomena—dynamic forces and resonance. The conversation led us to the idea of imprinting moments in time, the idea of photographs, the idea of ghosts. Tim said that for years he had felt a presence in the stairwell of his home which seemed about to jump on his back whenever he went up the stairs. He said he felt certain that at some point in the life of that space an intense event had taken place. It occurred to me that this impression of space if done with sufficient force

Doug Hollis

This project continued an extended series of works which are investigations into the form and sound of natural phenomena. They consist of large, linear surfaces which are pitched like a musical instrument in a particular site, as a tent would be pitched. They make the natural existing force forms both audible and visible by creating an interface which reacts as a sensing structure, much as the skin acts as a sensory surface through which information is assimilated and felt.

This was the first time I designed a piece by going to a site and simply allowing the dynamics of that place to create a text, a description, on which to base the construction. The piece was not just site-related but to a great extent site-created out of

(emotional, physical) could leave a space resonating with its occurrence forever. I wondered what Hiroshima "feels" like now. Pompeii, San Francisco? Do you still feel the flood when you see the river, Dayton?

This conversation, and the time I spent with the finished work, made the work ring true for me. It was not built to be a permanent structure but rather a temporary event made to draw attention to the place, to describe events already and always happening there and then pass on, leaving the place as it had been but impressed with its resonance.

Thanks to all.

Doug Hollis

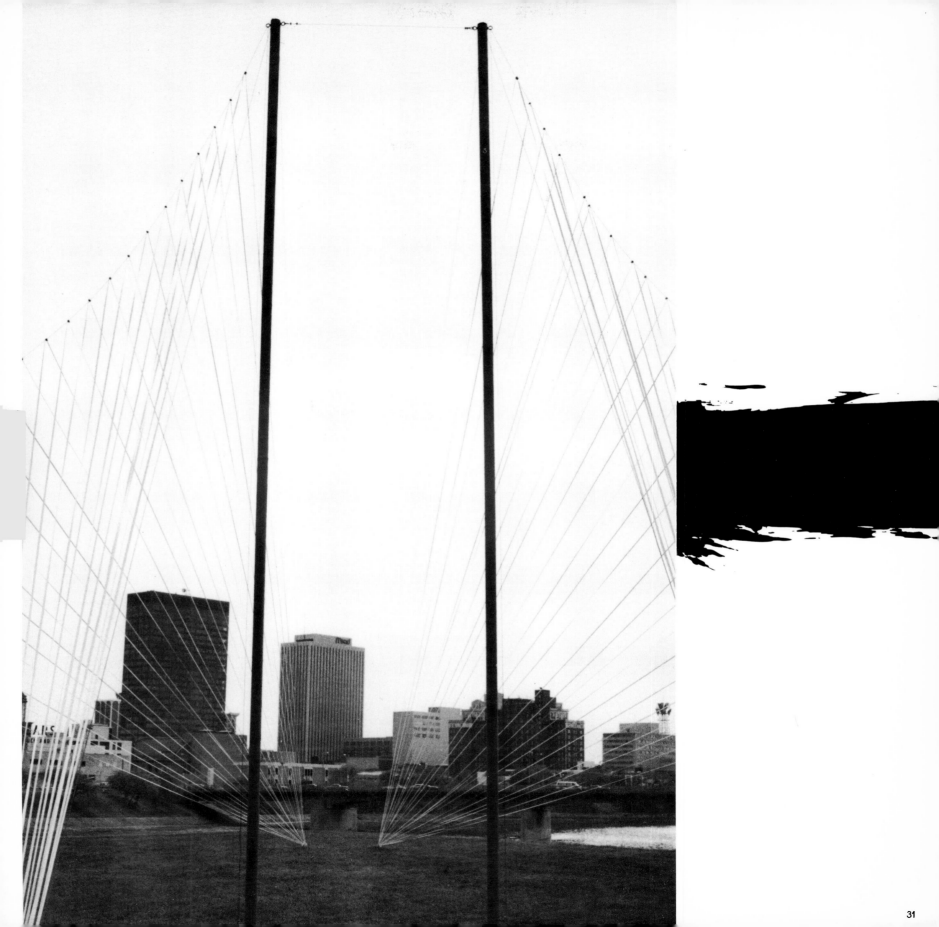

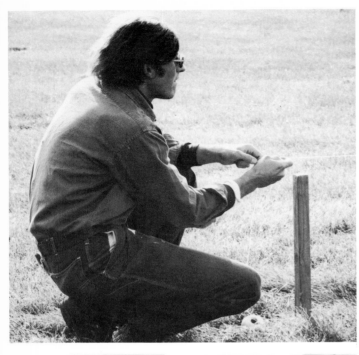

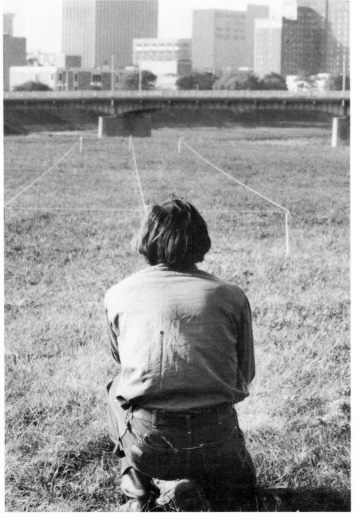

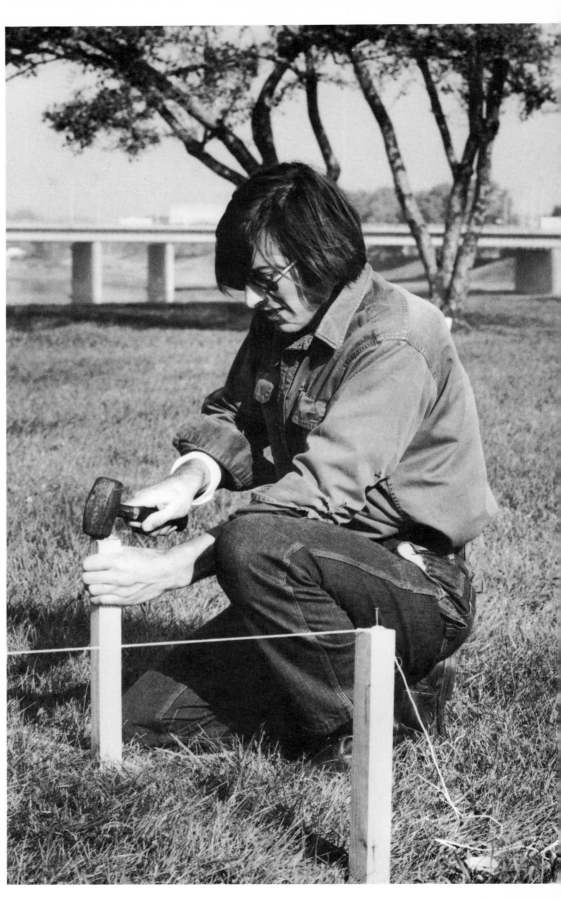

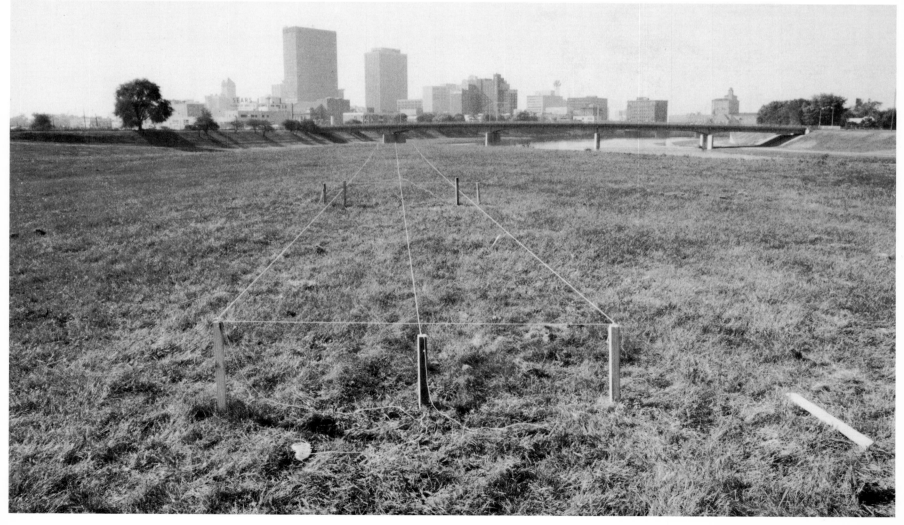

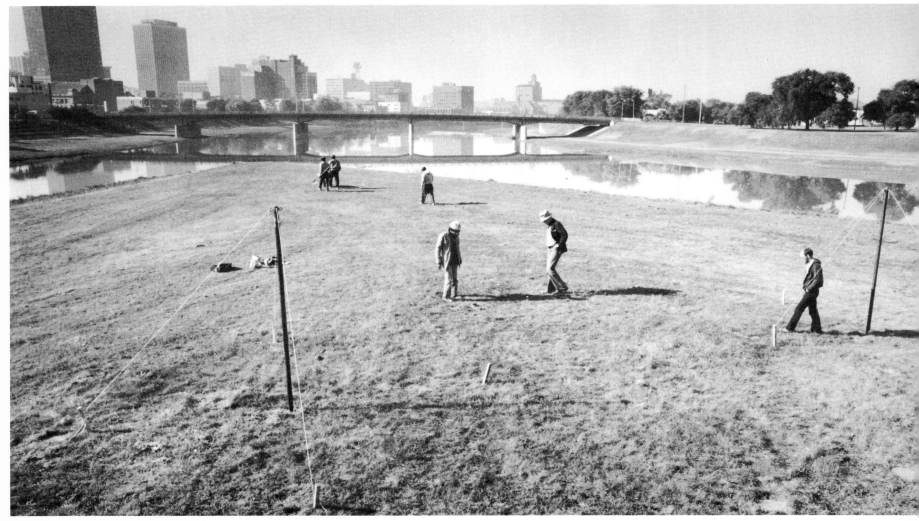

34

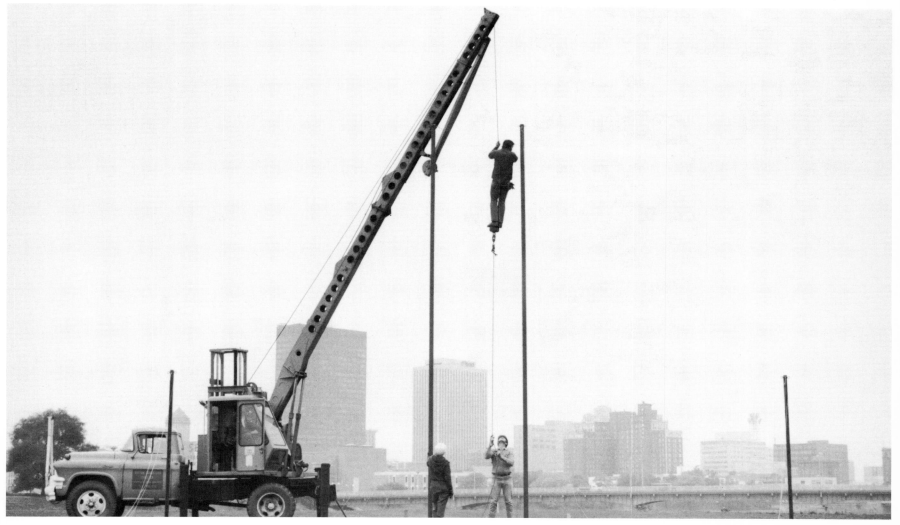

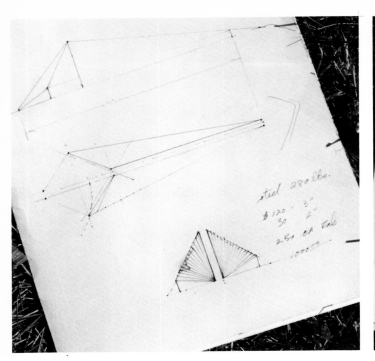

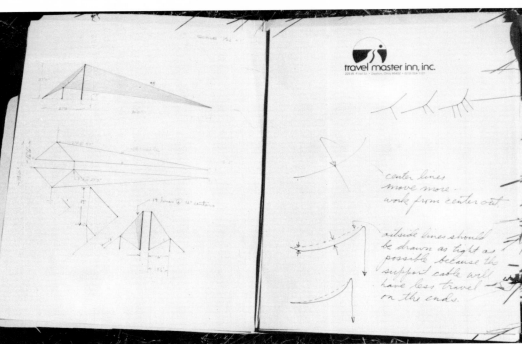

steel 280 lbs.

$120 · 3"
30 · 2"

250 CA Cab

1000.00

center lines
move more.
work from center out

outside lines should
be drawn as tight as
possible because the
support cable will
have less travel
on the ends.

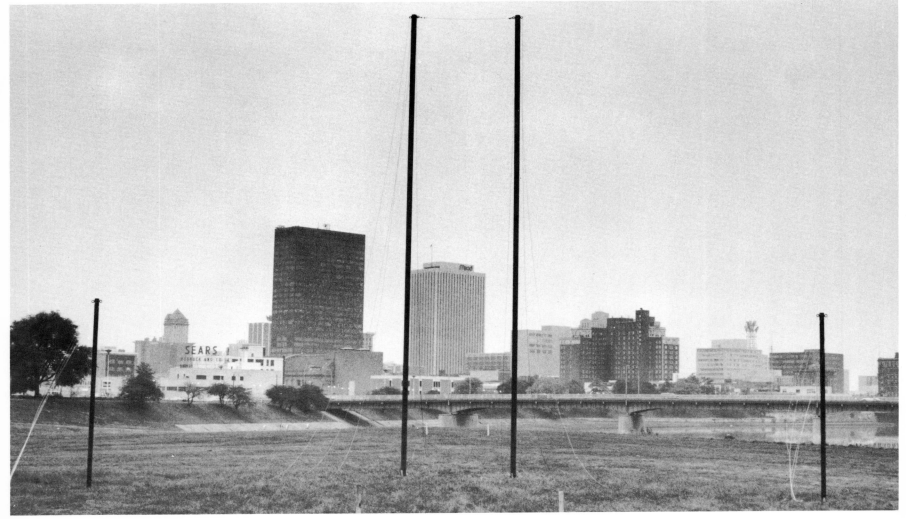

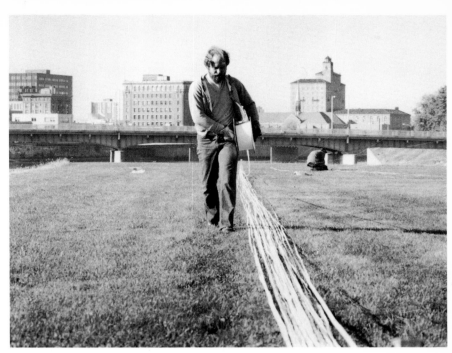

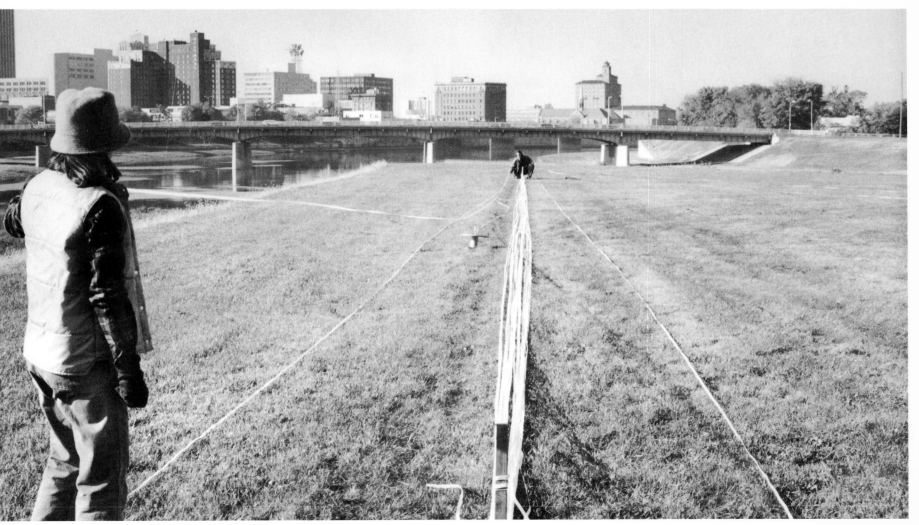

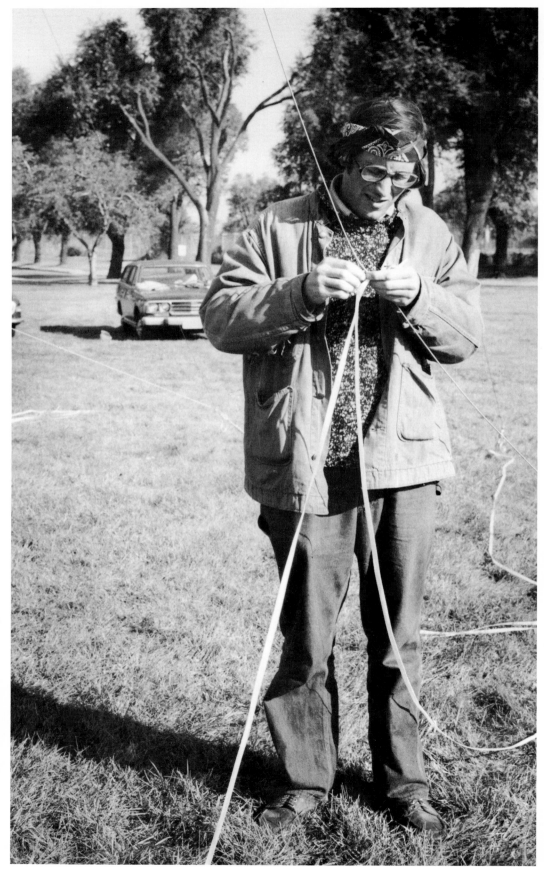

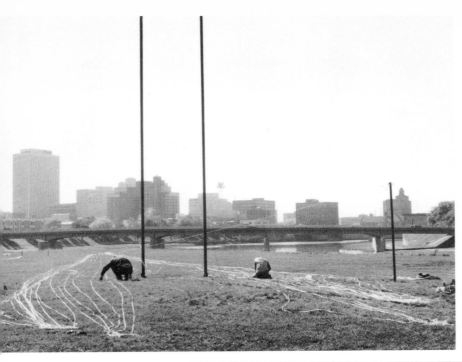

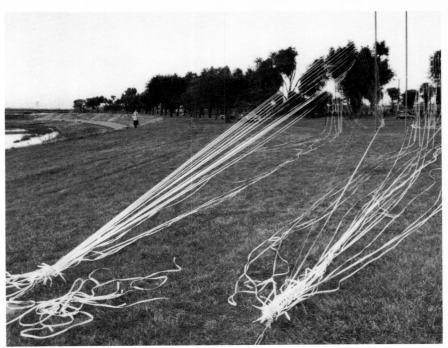

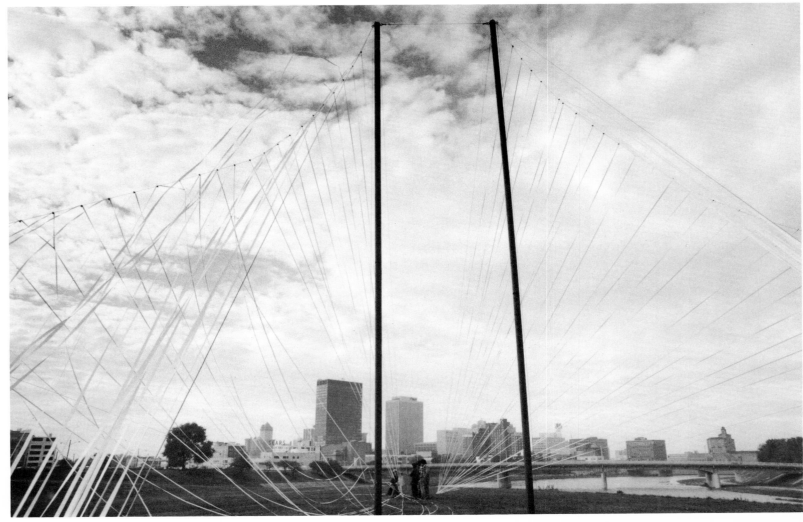

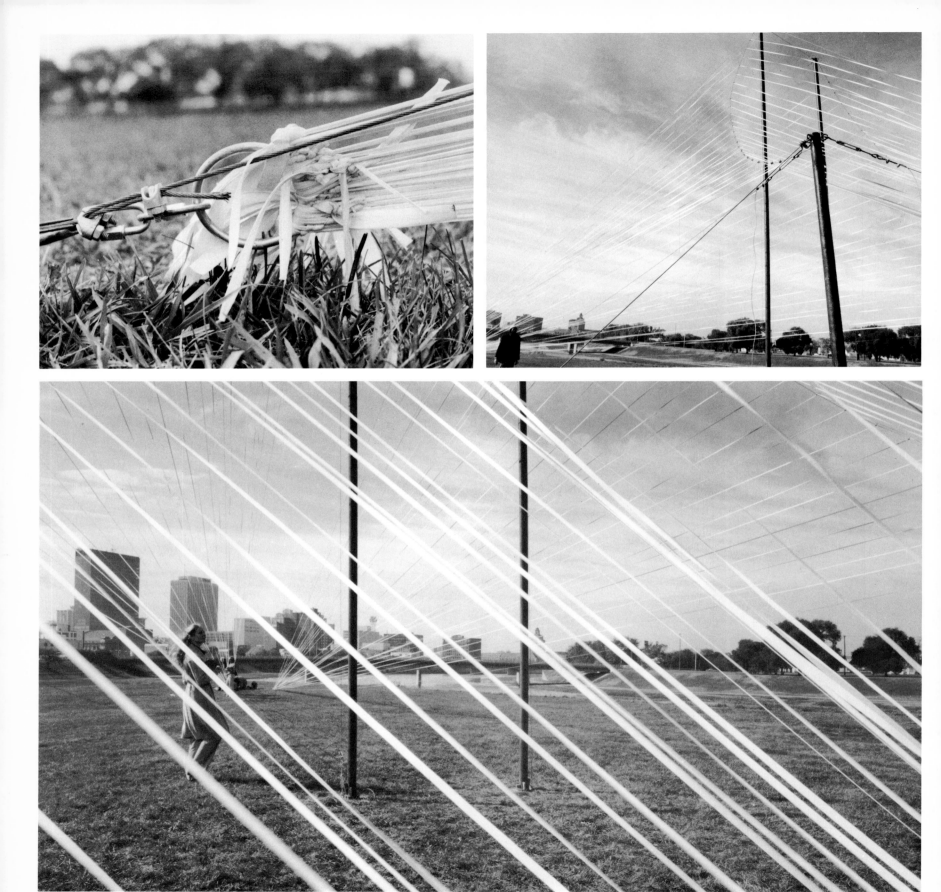

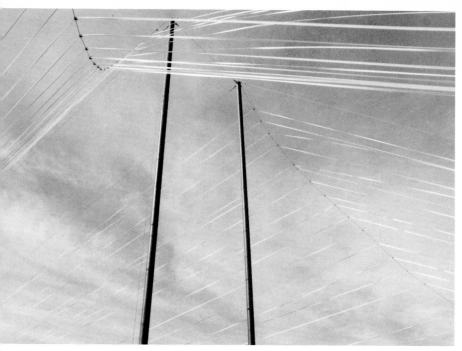

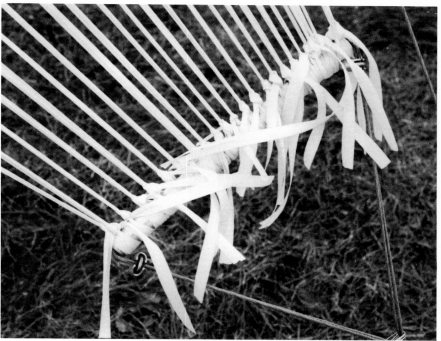

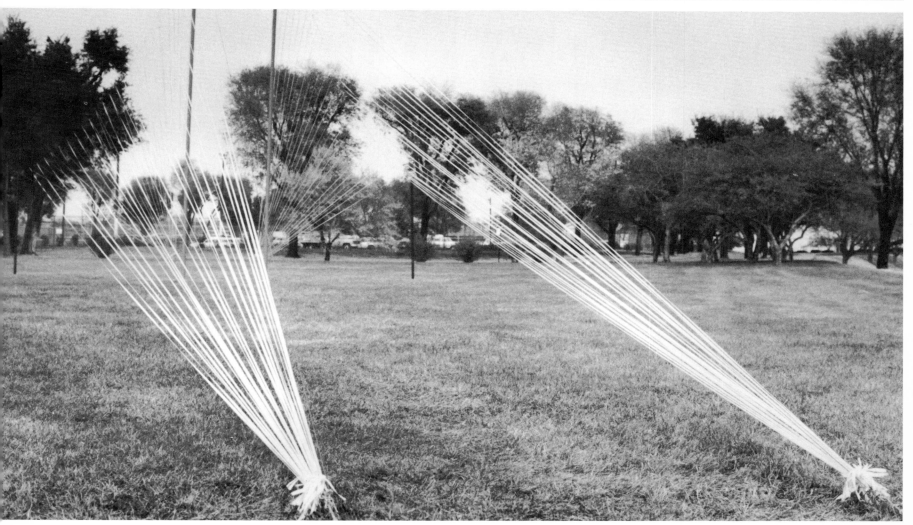

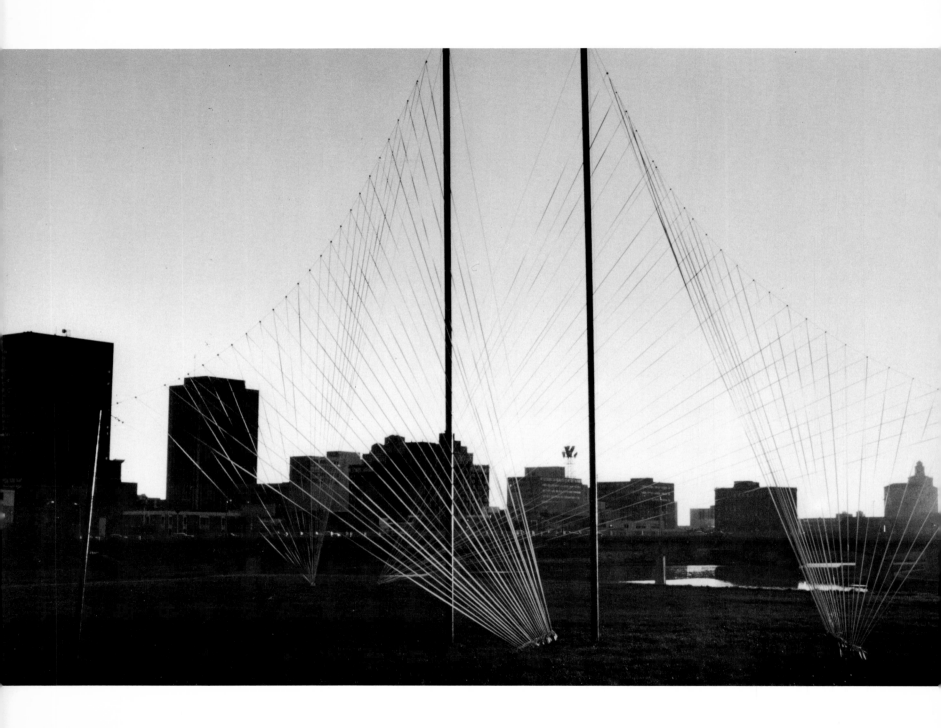

Spring 1979

Mary Miss

Michael Singer

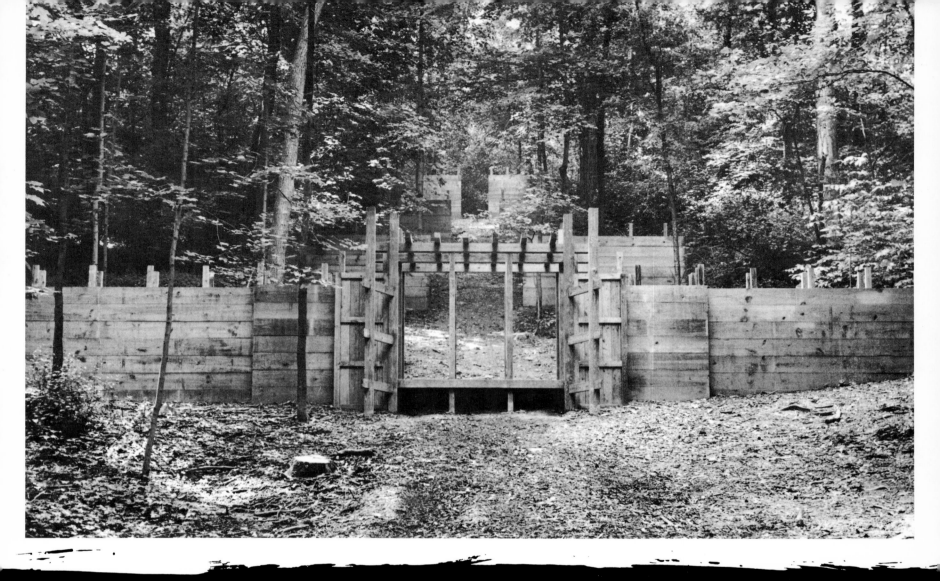

Mary Miss

STAGED GATES, Hills and Dales Park, Paw Paw Camp

Visited Dayton during the first week of May. The landscape is slightly rolling with dense growth; farms surround most of the populated areas.

Looking at structures in the area—
 The locks from the old canal. Stone with wood gates.

Barns, some of stone; octagonal and round.

Old covered bridges—differences in the inner structure of each.

Bilder's Atelya. Buildings of scrap materials of a visionary.

Run-down sections of town. Burned-out church, abandoned amusement park.

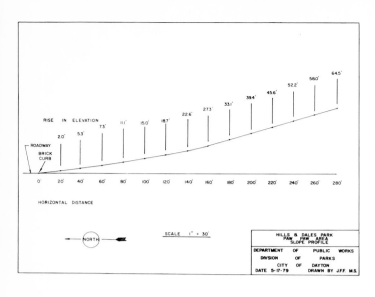

RISE IN ELEVATION

SCALE 1" = 30'

NORTH

HILLS & DALES PARK
PAW PAW AREA
SLOPE PROFILE
DEPARTMENT OF PUBLIC WORKS
DIVISION OF PARKS
CITY OF DAYTON
DATE 5-17-79 DRAWN BY J.F.F. M.S.

The site. Found a hillside in an extensive wooded area of a city park. A slight path goes up the hill; there is a gently bowl-shaped area with a large dead tree across it. Photograph site.

In N.Y. looking at the photos the ridge of the hill is much more important than I had realized. A series of trees in sets of two lead up to a stump at the top of the hill, focus on it.

Starting point for an idea. Had been thinking about corrals and fences in Colorado and Idaho; gateways, walls; the imagined space of stage sets being combined with 'real' space; using the gateway as a frame for the hillside, being a stage for that backdrop. Combine this information with the structures in Dayton.

Return to do construction in June. The idea for a structure that had developed out of all the previous information has to be integrated with, tied into the site . . . decisions of placement, scale, spacing and finally determining the actual form.

Mary Miss

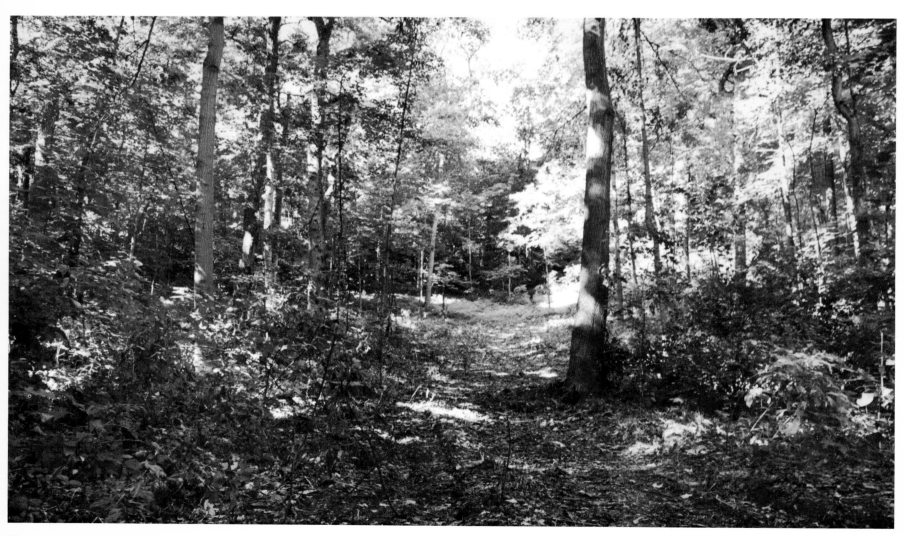

44

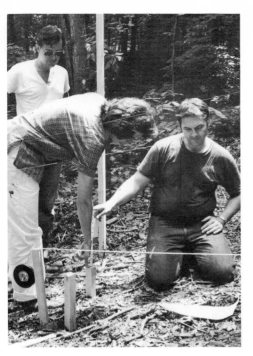

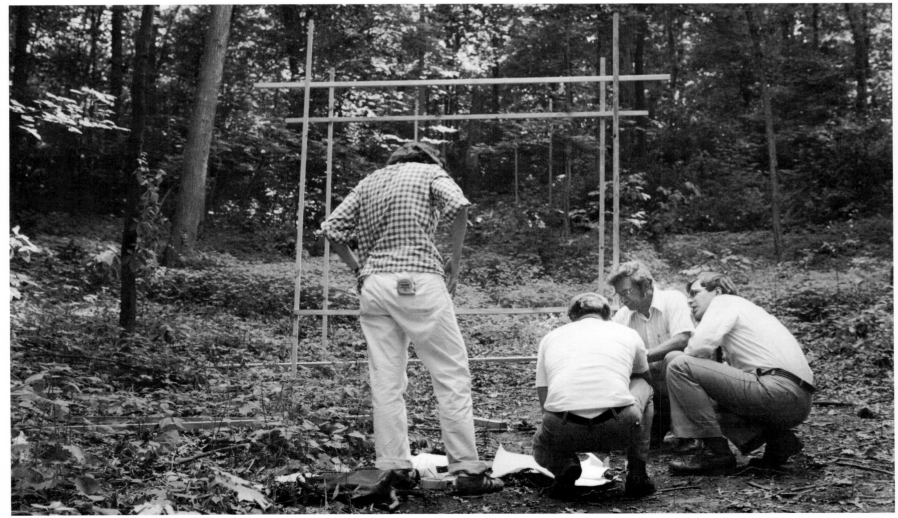

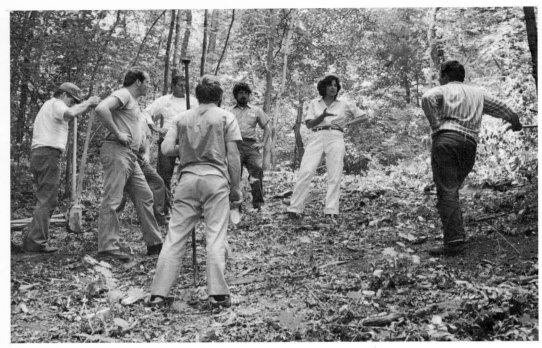

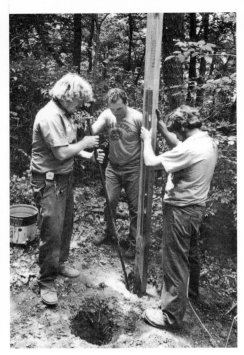

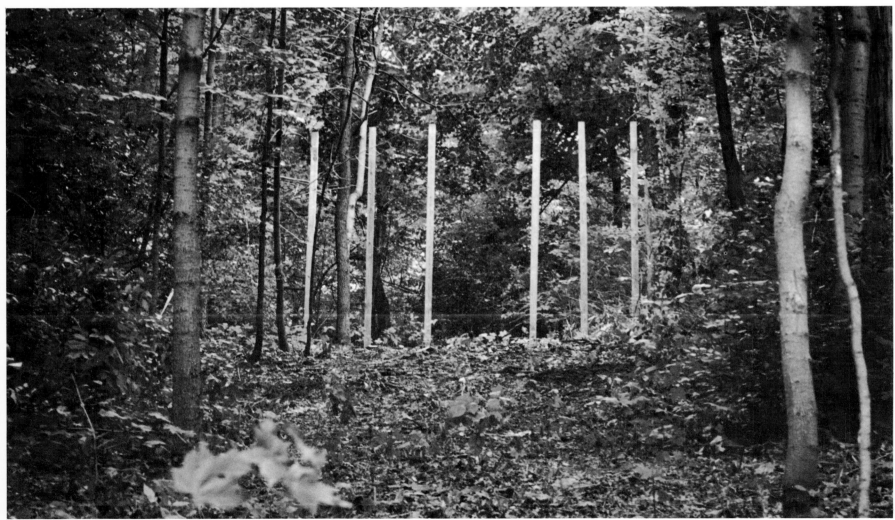

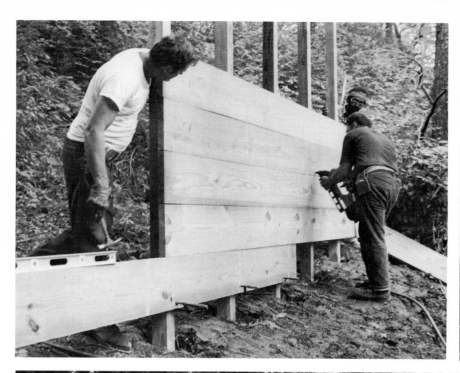
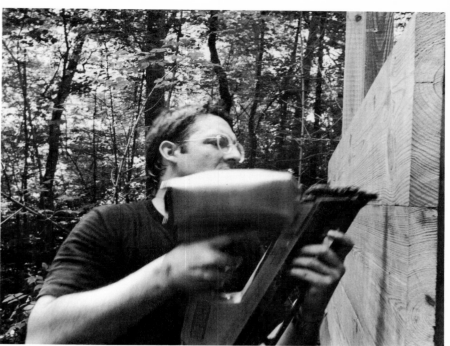
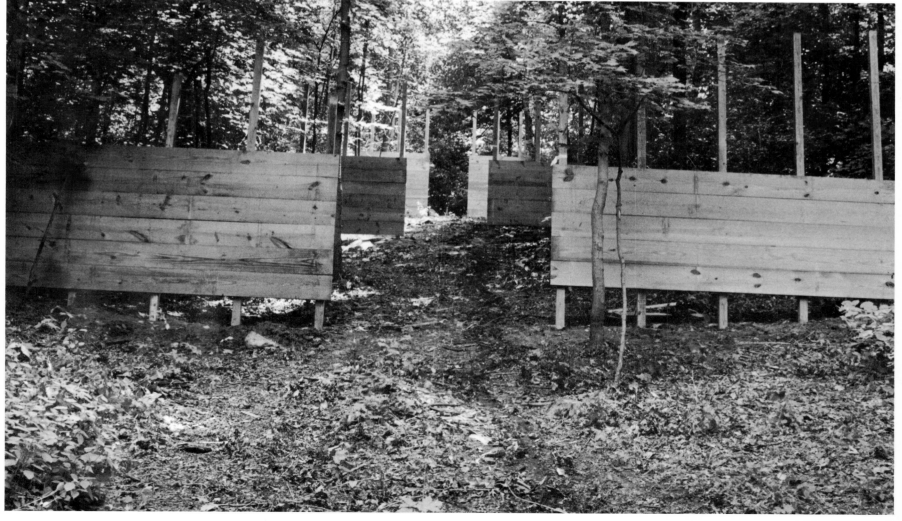

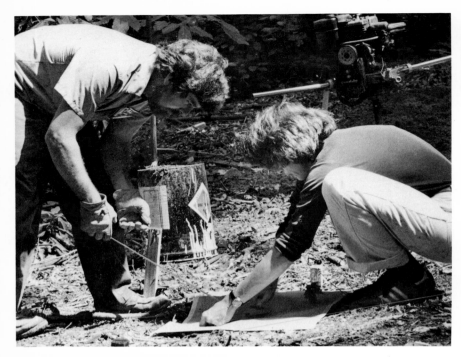
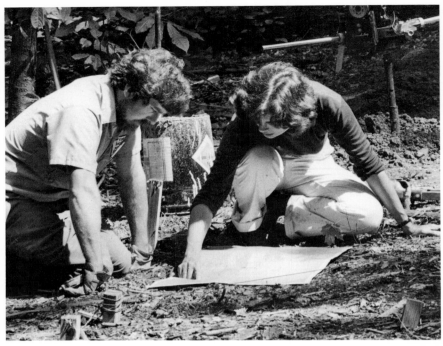
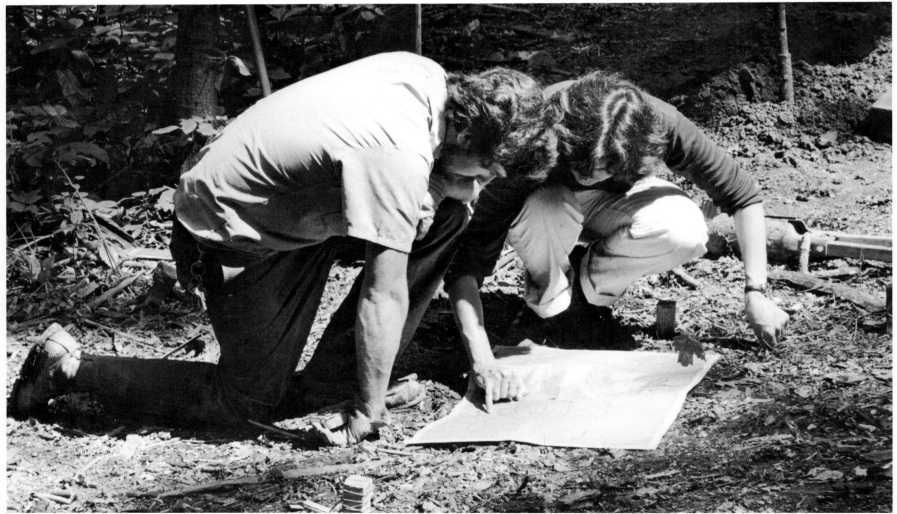

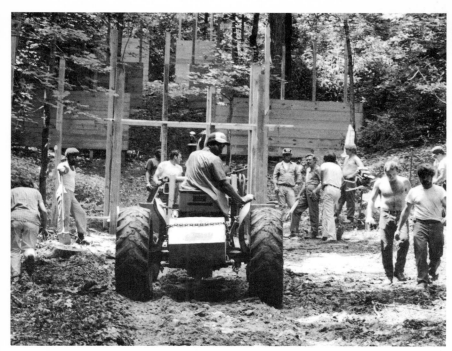
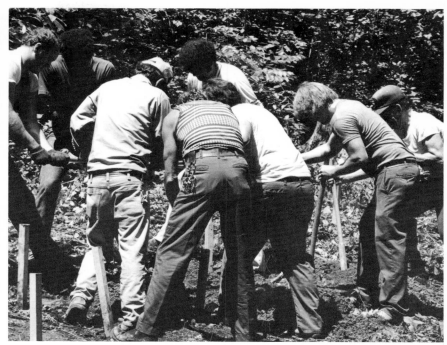
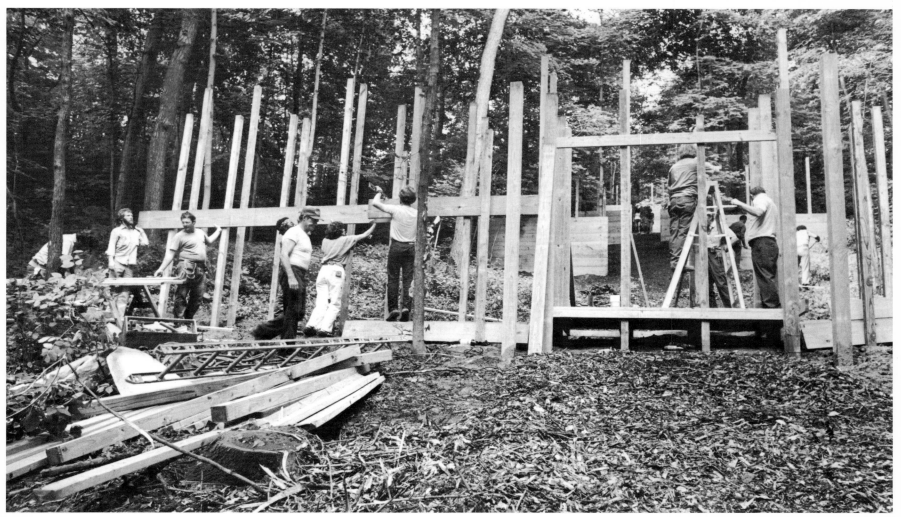

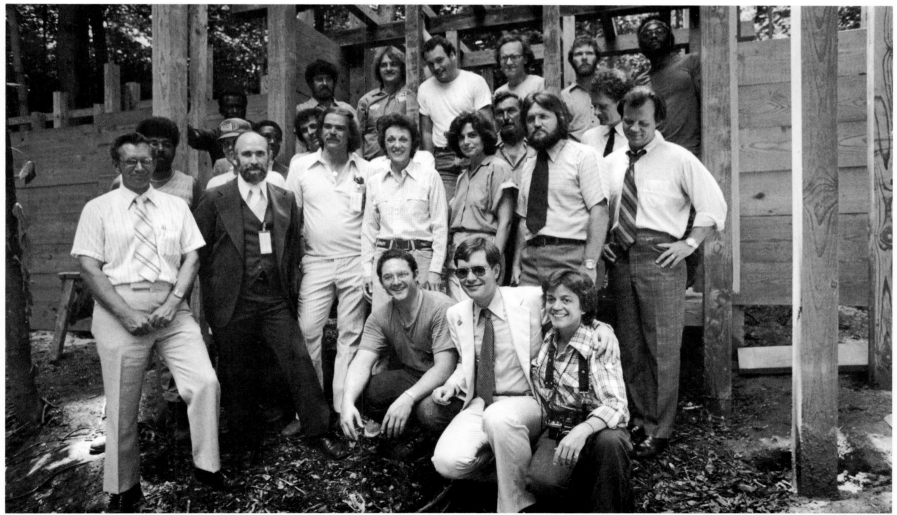

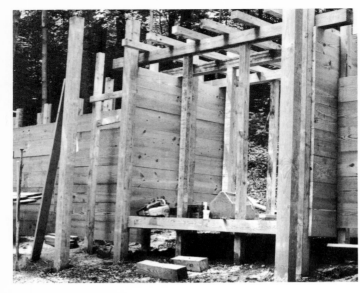

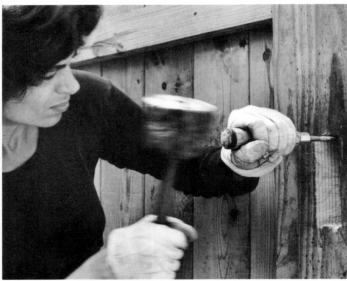

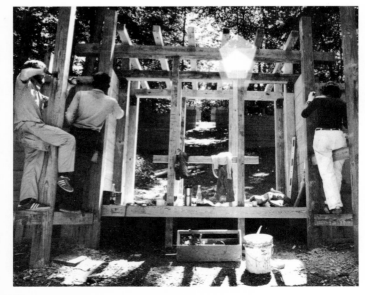

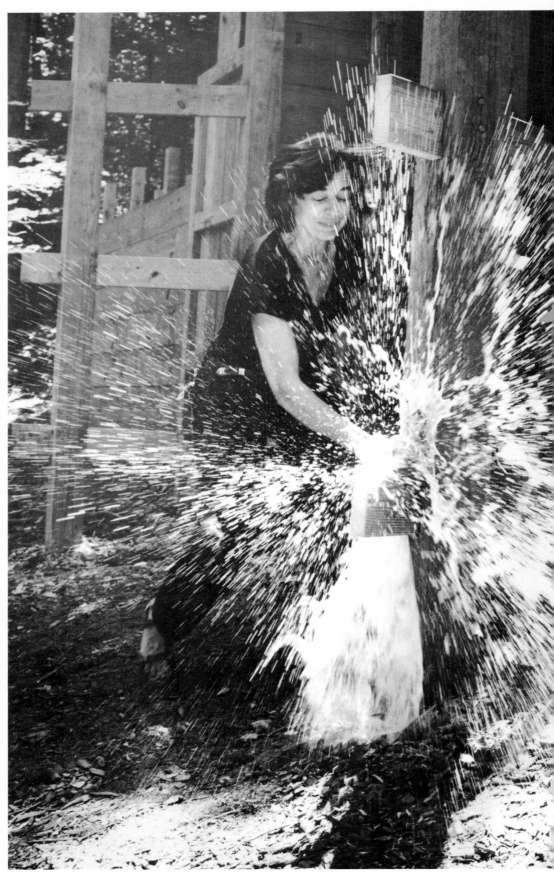

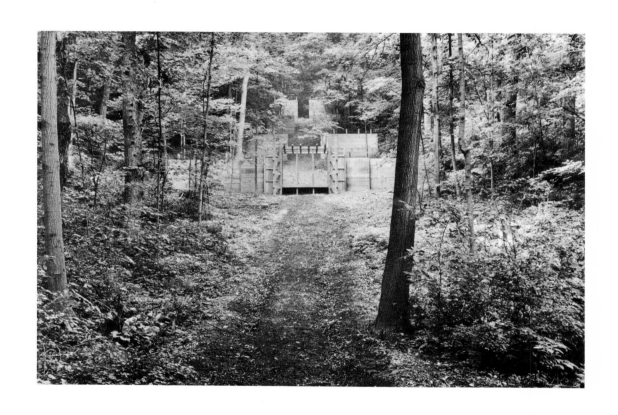

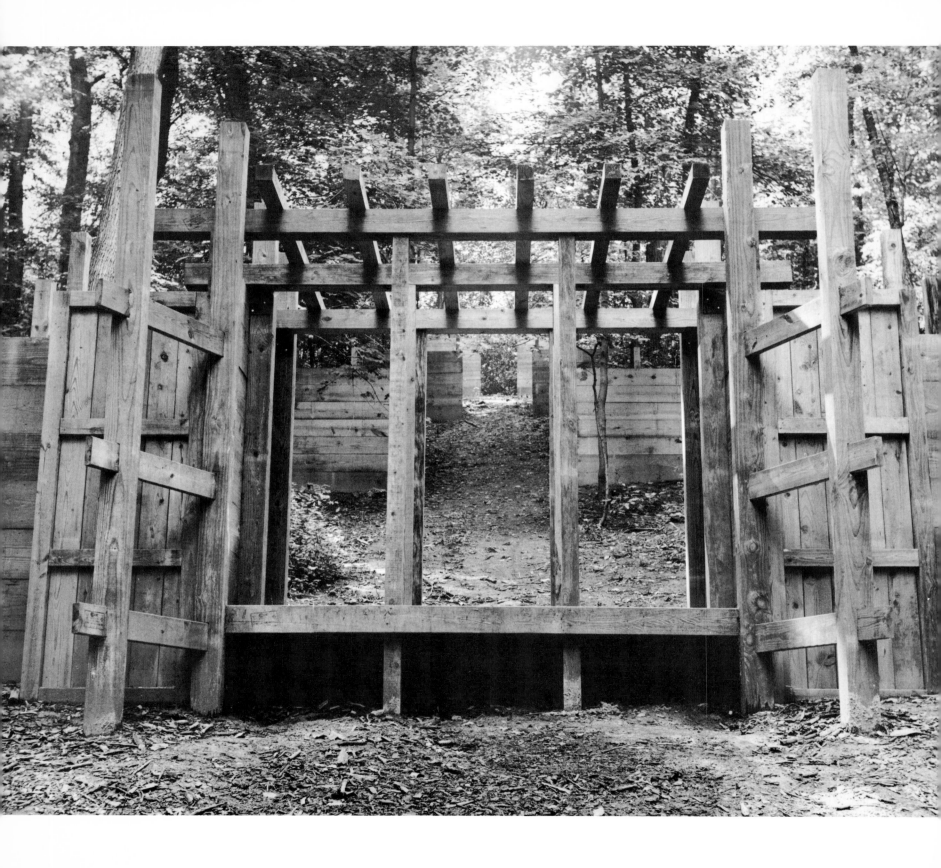

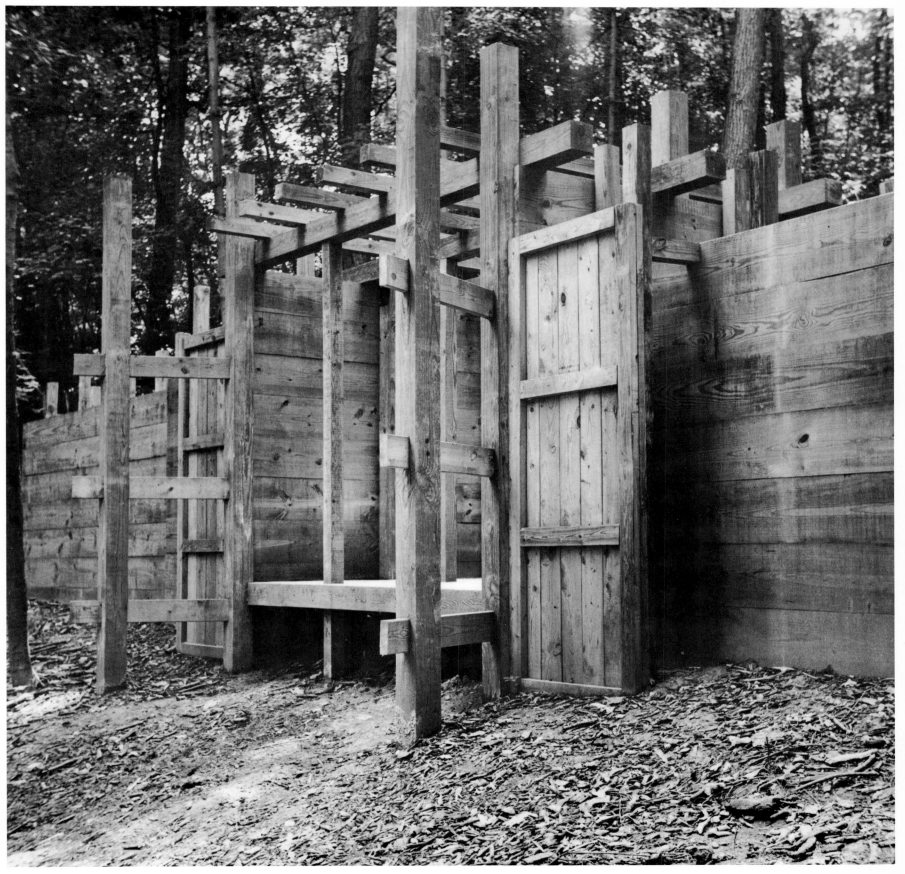

FIRST GATE RITUAL SERIES 4/79, DeWeese Park

The City Beautiful Council had the difficult task of discovering a site within the city of Dayton that was appropriate for my work, away from urban sights and sounds. Low-lying land in DeWeese Park which carries the annual overflow from the Stillwater River was the perfect answer. Situated on a north-south axis, the stream through this forest-swamp became the working area for FIRST GATE RITUAL SERIES 4/79.

The viewing point, a fallen tree that crossed over the stream about 150 feet from the piece, could best be approached wearing wader boots because the spring run-off created a flood situation throughout the area leaving most of the trees (hardwood) standing in three feet of water which reflected their arching tops and the sky. The higher forest floor was carpeted with the season's first wildflowers. Sounds of woodpeckers, ducks and birds returning from winter migration filtered through the forest in the same way as the light, moving east-west, came through the canopy of leafless trees. The piece was constructed of bamboo and phragmities, extending approximately 100 feet from its frontal plane back through the stream. The photographs represented here were taken at different times of the day from the same vantage point. The drawings are an ongoing series done on paper with chalk, charcoal and collage.

My appreciation to Lois Baker whose warmth and hospitality helped make my stay in Dayton very comfortable and to the City Beautiful Council for making this situation possible.

Michael Singer

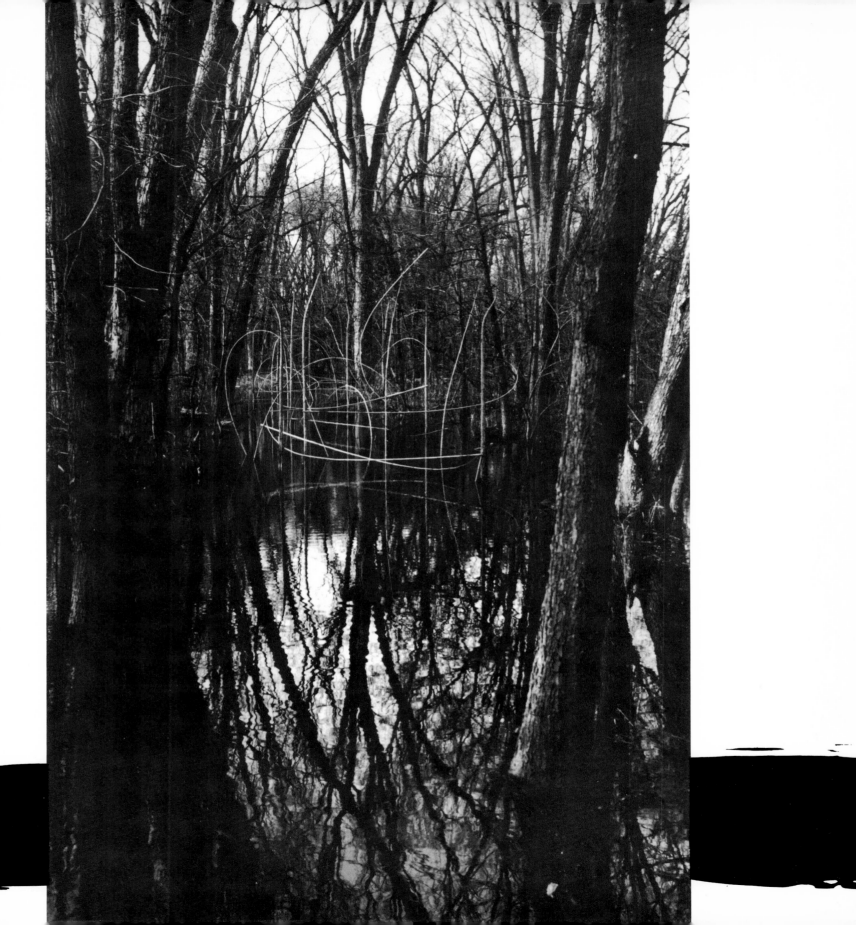

Commentary II

Meaning

Earl and Percy C. go fishing for a living. Scalloping in the winter, lobstering in the summer. They spend their lives on the sea, or rather with the sea.

Earl says he can see the wind. Not feel it on his neck or cheek. He sees the wind come down the bay at four o'clock in the morning.

Bill S. built boats over a long time. He too lives with the water.

Bill did not build his boats from plans or drawings. After a lifetime of watching wave upon wave, his hands "know" the proper angle of the bow and the curve of the sheer.

Poets see with their bodies as perhaps the ancestors did as surely the children do.

Names

The Greeks perceived the moon as a measure of time and it acquired the time bound name of *men*. The Romans perceived its light and called it *luna*. Each people anchored a separate aspect of the whole, grasping it firmly in name.

First Gate

Here is the entrance to the universe, seductive poem to a hungry earth. Kin to *torii*, bird and bird perch ancestral and impermanent. Archeologists will never find these things of light and man.

Ritual Series

A ritual perpetuation of the past. They are magical in the old sense and propitiate no gods. They are in sympathy with the world, they are their own environment, child's play and naive. They are about time.

Peter Rottmann

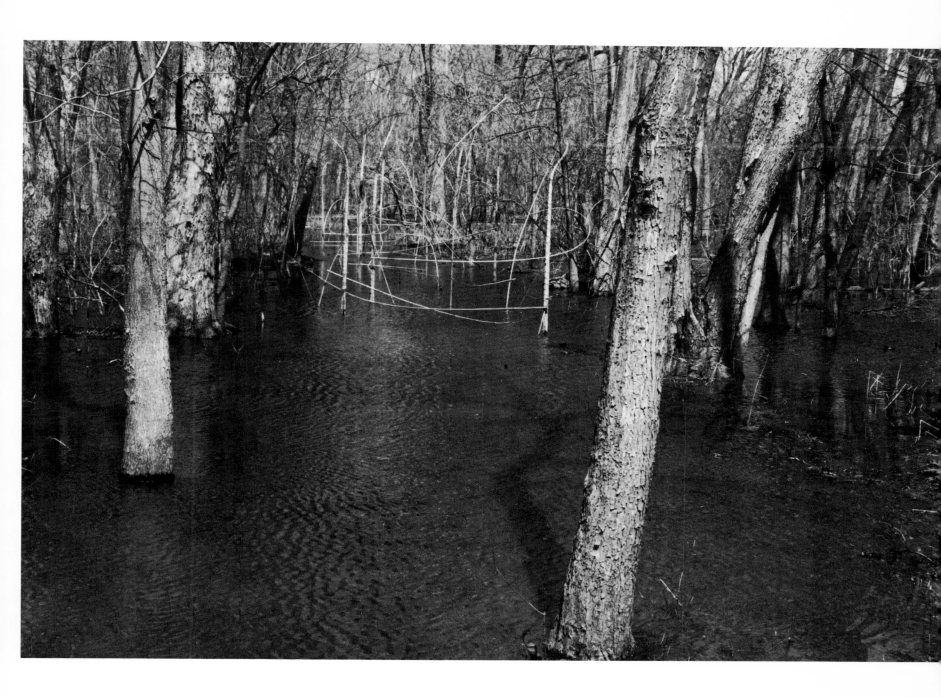

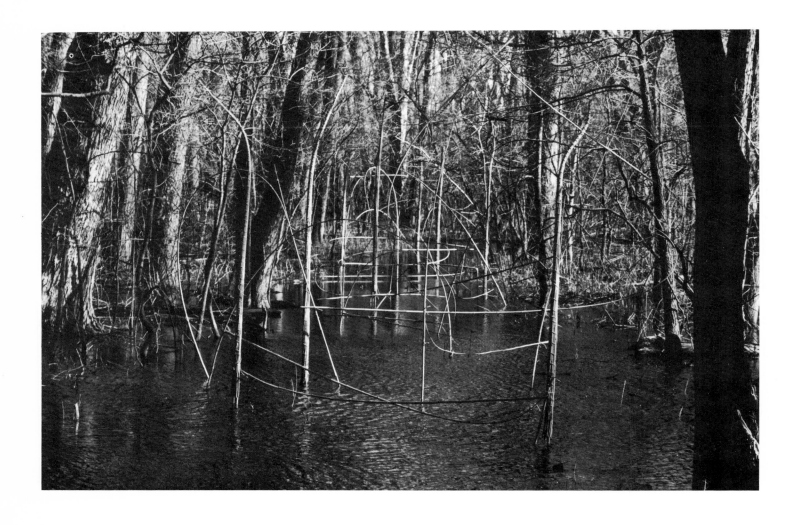

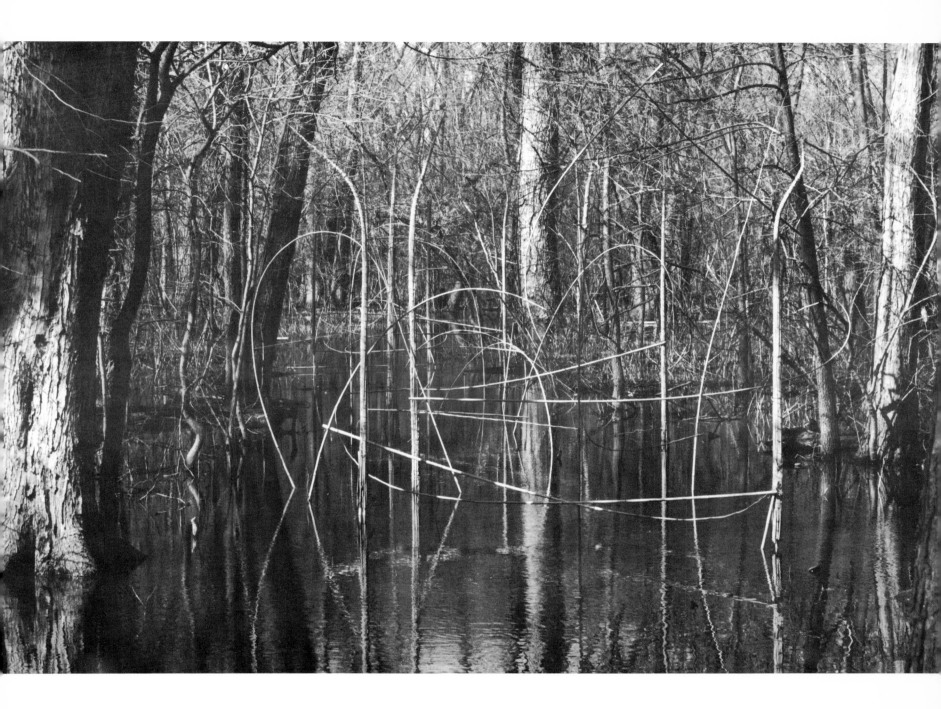

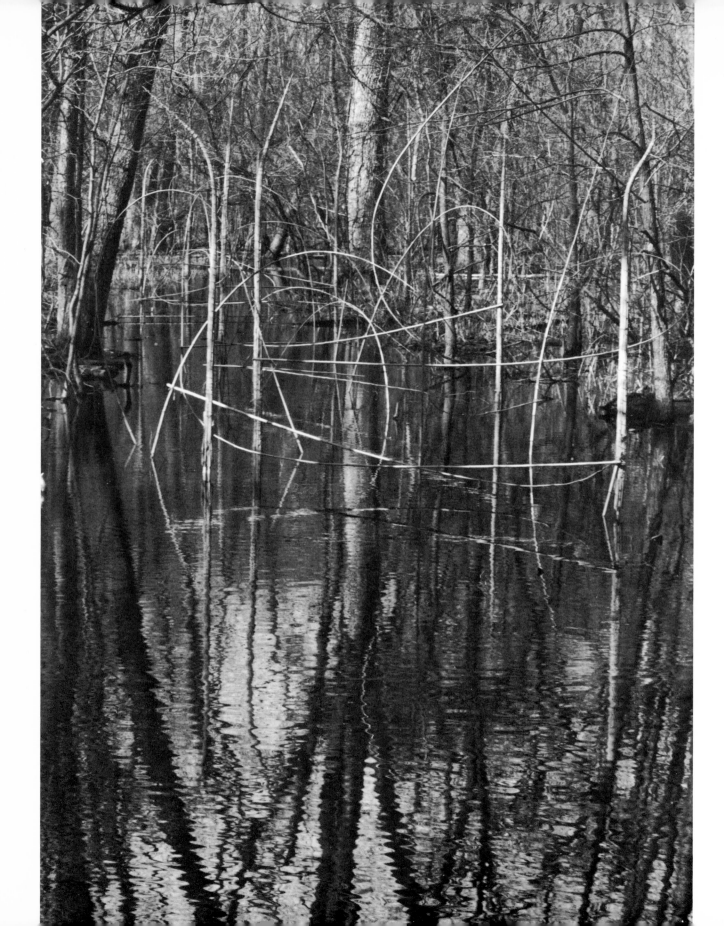

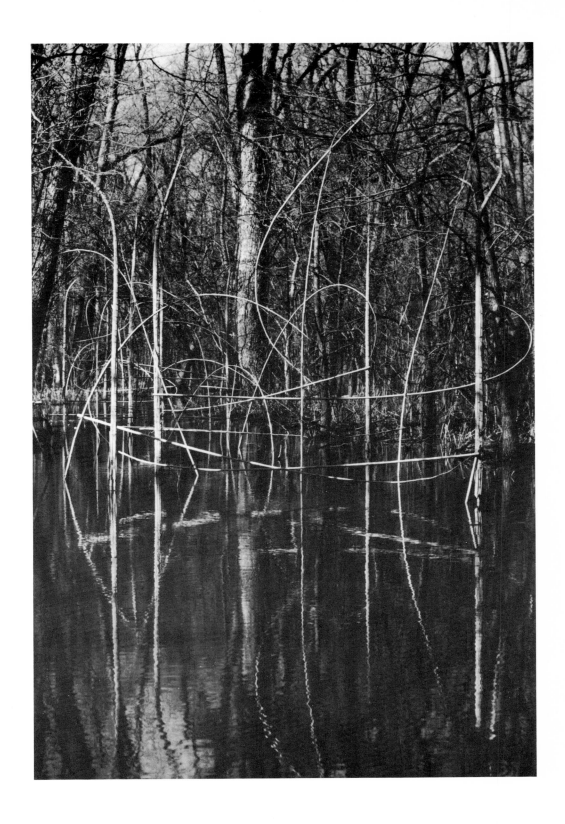

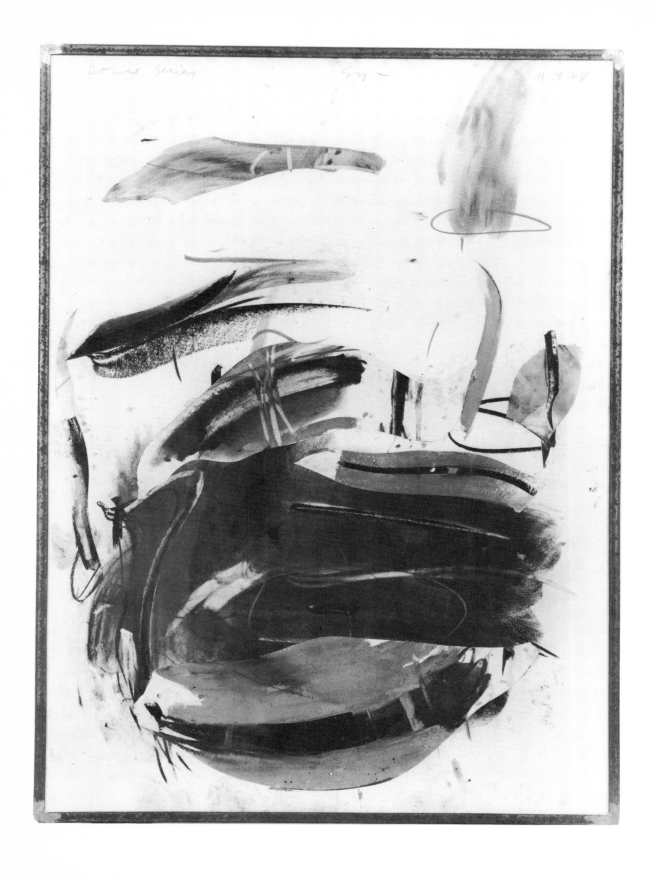

64

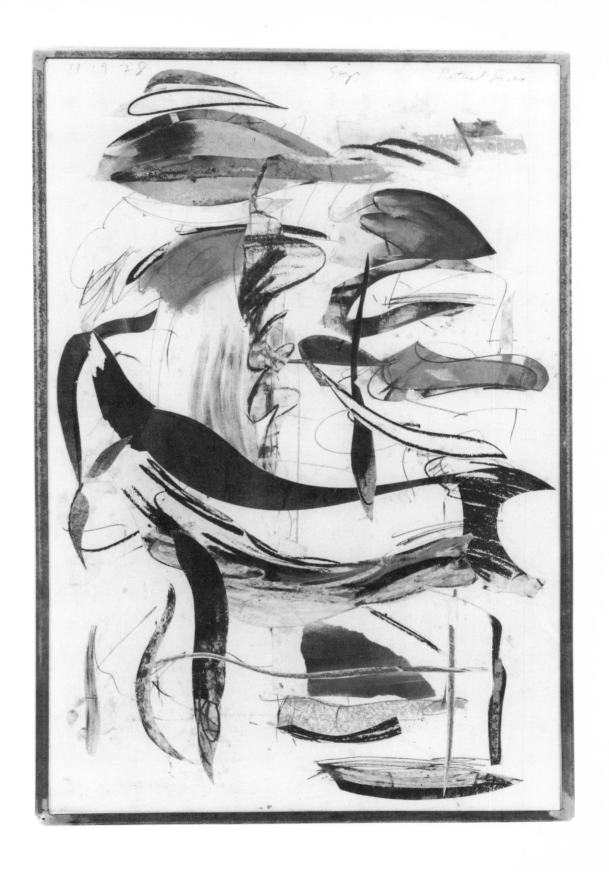

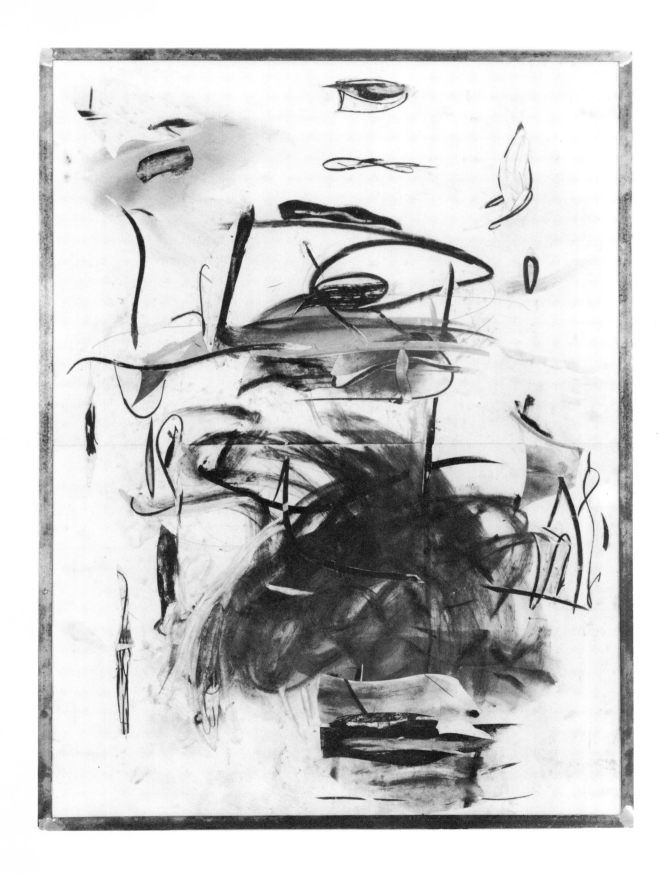

Biographies

and

Bibliographies

Jackie Ferrara

Born in Detroit, Michigan
Lives in New York City

Selected Individual Exhibitions

1973 A.M. Sachs Gallery, New York City
1974 A.M. Sachs Gallery, New York City
1975 Daniel Weinberg Gallery, San Francisco, California
Protetch-McIntosh Gallery, Washington, DC
1976 Max Protetch Gallery, New York City
1977 Ohio State University, Columbus
1979 University of Rhode Island, Kingston
1980 Max Protetch Gallery, New York City

Outdoor Installations

1973 Storm King Art Center, Mountainville, New York
1976 Dag Hammarskjold Plaza, New York City
1978 Minneapolis College of Art and Design, Minnesota
1979 Castle Clinton, Battery Park, New York City
1980 GSA Commission, Carbondale, Illinois

Selected Group Exhibitions

1970 "Sculpture Annual," Whitney Museum of American Art, New York City
1972 "GEDOK American Women Artists," Kunsthaus, Hamburg, West Germany
1973 "Biennial," Whitney Museum of American Art, New York City
1974 "7 Sculptors," Institute of Contemporary Art, Boston, Massachusetts
1976 "New York-Downtown Manhattan: Soho," Berlin Festival, Akademie der Kunst, Berlin, West Germany
1977 "Ferrara, Lichtenstein, Nevelson, Ryman," Sarah Lawrence College, Bronxville, New York
"Works and Projects of the Seventies," Institute for Art and Urban Resources, P.S. 1, Long Island City, New York
"Drawings for Outdoor Sculpture: 1946-77," John Weber Gallery, New York City
1978 "Art for Corporations," Penthouse Gallery, The Museum of Modern Art, New York City

"Architectural Analogues," Downtown Branch Museum, Whitney Museum of American Art, New York City
"Inaugural Exhibition," Max Protetch Gallery, New York City
1979 "Biennial Exhibition," Whitney Museum of American Art, New York City
"Drawing About Drawing," Ackland Memorial Art Museum, University of North Carolina, Chapel Hill
"Small is Beautiful," Albright College, Reading, Pennsylvania
"Models for Large-Scale Sculpture," Feigenson/Rosenstein, Detroit, Michigan
"The Minimal Tradition," Aldrich Museum of Contemporary Art, Ridgefield, Connecticut
1980 "Intricate Structure/ Repeated Image," Tyler School of Art, Philadelphia, Pennsylvania
"Echoes of the Past," Wave Hill, Riverdale, New York

Selected Bibliography

1974 Anderson, Laurie, "Reviews," ARTFORUM, vol 12, #5, January, p. 80
1975 Bourdon, David, "A Pioneer Abstractionist . . . Lands Here Finally," THE VILLAGE VOICE, vol 20, #43, October 27, p. 124
Heinemann, Susan, "Reviews," ARTFORUM, vol 13, #6, February, p. 66
Ratcliff, Carter, "Reviews," ART SPECTRUM, vol 1, #1, January, p. 70
1976 Klein, Michael R., FOUR ARTISTS, Williams College Museum of Art, Williamstown, Massachusetts (catalogue)
Pincus-Witten, Robert, "Jackie Ferrara: The Feathery Elevator," ARTS MAGAZINE, vol 51, #3, November, pp. 104-108
1977 Perreault, John, "How It All Stacks Up," THE SOHO WEEKLY NEWS, vol 4, #15, January 13, p. 20
Perrone, Jeff, "Reviews," ARTFORUM, vol 15, #5, January, p. 62
1978 Onorato, Ronald J., "Jackie Ferrara," ARTS MAGAZINE, vol 53, #4, December, p. 16

Zimmer, William, "Ferrara's Wood," THE SOHO WEEKLY NEWS, vol 6, #5, November 2, p. 31
1979 Berlind, Robert, "Reviews," ART IN AMERICA, vol 67, #2, March/April, p. 153
Pincus-Witten, Robert, "Entries: Cutting Edges," ARTS MAGAZINE, vol 53, #10, June, pp. 105-109
Shapiro, Lindsay, "Reviews," CRAFT HORIZONS, vol 39, #1, February, p. 51
Whelan, Richard, "Discerning Trends at the Whitney," ARTnews, vol 78, #4, April, pp. 84-87

Richard Fleischner

Born in New York City, 1944
Lives in Providence, Rhode Island

Selected Individual Exhibitions

1971 Hopkins Art Center, Dartmouth College, Hanover, New Hampshire
1973 Terry Dintenfass Gallery, New York City
1975 Terry Dintenfass Gallery, New York City
1976 Dag Hammarskjold Plaza, New York City
1977 University Gallery, University of Massachusetts, Amherst
1979 Max Protech Gallery, New York City

Selected Group Exhibitions

1970 "Humanism in New England Art," DeCordova Museum, Lincoln, Massachusetts
1972 "Small Environments," Madison Art Center and University Gallery, Southern Illinois University, Carbondale
1973 "The Albert Pilavin Collection: Twentieth Century American Art II," Museum of Art, Rhode Island School of Design, Providence
1974 "20th Annual Drawings and Small Sculpture Show," Ball State University, Muncie, Indiana
"Awards Exhibition," The American Academy of Arts and Letters and the National Institute of Arts and Letters, New York City
1975 "Labyrinths," Wheaton College, Norton, Massachusetts (traveling exhibition)
"The Boston Bicentennial Art Collection," Institute of Contemporary Art, Massachusetts
1976 "Sculpture Sited," Nassau County Museum of Fine Arts, Roslyn, New York
Artpark, Lewiston, New York
1977 "Probing the Earth: Contemporary Land Projects," Hirshhorn Museum and Sculpture Garden, Smithsonian Institution, Washington, DC
"Le Jardin," Jardin Botanique, National de Bruxelles, Belgium
"Documenta 6," Kassel, West Germany
1978 "Sculpture/Nature," Center d'Arts Plastiques, Contemporins de Bordeaux, France

"Private Images: Photographs by Sculptors," Los Angeles County Museum, California
1979 "Small is Beautiful," Albright College, Reading, Pennsylvania
"The Image of the Self," Hampshire College, Amherst, Massachusetts
"Art and Architecture, Space and Structure," Protetch-McIntosh Gallery, Washington, DC
1980 "Fence Covered Fence," Environmental Sculpture Project, National Fine Arts Commission for the XIII Winter Olympic Games, Lake Placid, New York
1980 "Untitled," Social Security Administration Computer Center, Baltimore, Maryland

Selected Sited Works

1971 HAY LINE, baled hay
HAY MAZE, baled hay
HAY INTERIOR, baled hay
1972 BLUFF, planted Sudan grass
1973 TUFA MAZE, tufa stone
1974 SOD MAZE, sod over earth
1975 SOD DRAWING, inlaid steel channel and sod
1976 WOOD INTERIOR, spruce, hemlock, pine
1977 FLOATING SQUARE, sod and earth
COW ISLAND PROJECT, granite
1978 CHAIN LINK MAZE, chain link fabric

Selected Bibliography

1973 Canaday, John, "Art," THE NEW YORK TIMES, vol 522, April 21, p. 23
1974 Hughes, Robert, "Sea with Monuments," TIME, vol 104, #10, September 2, p. 60
1975 Russell, John, "Art," THE NEW YORK TIMES, vol 525, October 11, p. 23
1976 Onorato, Ronald J., "The Modern Maze," ART INTERNATIONAL, vol 20, #4-5, April/May, pp. 21-25
Russell, John, "Art People," THE NEW YORK TIMES, vol 525, August 27, p. C12
Stimson, Paul, "Review of Exhibitions: Richard Fleischner at Dintenfass," ART IN AMERICA, vol 64, #2, March/April, pp. 106-107
1977 Onorato, Ronald J., "Cow Island Project," ARTFORUM, vol 16, #3, November, pp. 70-71
Perlberg, Deborah, " 'Sculpture Sited,' Nassau County Museum of Art," ARTFORUM, vol 15, #5, January, pp. 67-68
1978 Wright, Martha McWilliams, "Washington: Some Winter Exhibitions," ART INTERNATIONAL, vol 22, #1, January, pp. 61-67
1979 Foote, Nancy, "Monument-Sculpture-Earthwork," ARTFORUM, vol 18, #2, October, pp. 32-37
Lippard, Lucy, "Complexes: Architectural Sculpture in Nature," ART IN AMERICA, vol 67, #1, January/February, p. 95
Onorato, Ronald J., "Chain Link Maze," ARTFORUM, vol 17, #7, March, p. 68
Pincus-Witten, Robert, "Entries: Cutting Edges," ARTS MAGAZINE, vol 53, #10, June, pp. 105-109
Stevens, Mark, "The Dizzy Decade," NEWSWEEK, vol 93, #13, March 26, pp. 88-94

Born in Ann Arbor, Michigan, 1948
Lives in Berkeley, California

Selected Group Exhibitions

1968 "Laser, Sound and Air,"
Cranbrook Museum of Art,
Bloomfield Hills, Michigan
1977 Hallswalls Gallery, Buffalo,
New York
"Seven Years of Crazy Love,"
Beaubourg Museum, Paris,
France
1978 "Artparkart III," Artist Spaces,
New York City
1979 "Wind Organ," Los Angeles
Institute of Contemporary
Art, California; P.S. 1, Long
Island City, New York
1980 "Phenomena Compound for
Paradox Bay,"
Environmental Sculpture
Project, National Fine Arts
Commission for the XIII
Winter Olympic Games,
Lake Placid, New York

Selected Installations

1972 "Air Forms," Cranbrook
Museum of Art, Bloomfield
Hills, Michigan
1975 "Sky Soundings," And/Or
Gallery, Seattle,
Washington
1976 "Aeolian Harp," San
Francisco Exploratorium,
California
1977 "Sound Site," Artpark,
Lewiston, New York
1978 "Vortex," San Francisco
Exploratorium, California
"Apparition," Joslyn Art
Museum, Omaha,
Nebraska
"Soundings," Seattle Arts
Festival, Washington
1979 "Telltales: Conversations
With the Wind," San
Francisco Art Institute,
California
"Untitled," College of Santa
Fe, New Mexico
"Fencing With Words:
Bluebird's Castle," The
Farm, San Francisco,
California
"Aeolian Organ," Standing
Bear Lake, Omaha,
Nebraska

Selected Bibliography

1976 Zipkin, Michael, "In the Wind
There is Music,"
ODALISQUE, vol 1, #7,
October 14, p. 3
1977 Edelman, Sharon, ARTPARK:
THE PROGRAM in VISUAL
ARTS, Lewiston, New York
(catalogue)

Foran, Jack, "Wind Sings the
Artist's Song," NIAGARA
FALLS GAZETTE, vol 85,
#134, July 31, p. 4-B
Subtle, Susan, "Best Bets,"
NEW WEST, vol 2, #2,
January 17, p. NC-19
Thalenberg, Eileen, "Site
Work," ARTSCANADA,
#216/217, October/
November, p. 16
Willig, Nancy Tobin,
"Reviews," ARTnews,
vol 76, #9, November,
p. 197
1978 Enslow, Daphne, "Aeolian
Harp, Rain Piano and
Chanting Harp," SEATTLE
ARTS, vol 2, #1, August,
p. 3
1979 ARTWEEK, vol 10, #15,
April 14, p. 12
Hillerman, Anne, "Making
Music With the Wind," THE
NEW MEXICAN WEEKEND,
April 27, p. 4
Hollis, Doug, "The Artist's
View," EXPLORATORIUM,
vol 3, #4, October/
November, p. 4
Rosenthal, Adrienne, "The
Shapes of Sound,"
ARTWEEK, vol 10, #26,
August 11, p. 9
Smith, Mary Treynor, "Artist
Doug Hollis Returns to
Omaha," THE SUN
NEWSPAPERS of OMAHA,
vol 81, #35, August 9,
p. 7-C
Wilhite, Bob, SOUND, Los
Angeles Institute of
Contemporary Art,
California (catalogue)

Doug Hollis

209305

Mary Miss

Born in New York City, 1944
Lives in New York City

Selected Individual Exhibitions

1971 55 Mercer Gallery, New York City
1972 55 Mercer Gallery, New York City
1975 Salvatore Ala Gallery, Milan, Italy
 Rosa Esman Gallery, New York City
1976 The Museum of Modern Art, New York City
1978 Nassau County Museum of Fine Arts, Roslyn, New York
1979 Minneapolis College of Art and Design, Minnesota
1980 Max Protetch Gallery, New York City

Outdoor Installations

1968 "Stakes and Ropes," Colorado Springs, Colorado
1969 "V's in the Field," Liberty Corner, New Jersey
1973 "Untitled," Allen Memorial Art Museum, Oberlin College, Oberlin, Ohio
 "Untitled," Landfill, Battery Park City, New York
1974 "Sunken Pool," Greenwich, Connecticut
1976 " 'Blind' Set," Artpark, Lewiston, New York
1979 Environmental Sculpture Project, National Fine Arts Commission for the XIII Winter Olympic Games, Lake Placid, New York

Selected Group Exhibitions

1970 "1970 Annual Exhibition: Contemporary American Sculpture," Whitney Museum of American Art, New York City
1971 "Twenty-Six Contemporary Women Artists," The Aldrich Museum of Contemporary Art, Ridgefield, Connecticut
1972 "GEDOK American Women Artists," Kunsthaus, Hamburg, West Germany
1973 "1973 Biennial Exhibition: Contemporary American Art," Whitney Museum of American Art, New York City
 "Seven: Selections from the Art Lending Service, Penthouse Exhibition," The Museum of Modern Art, New York City
1974 "Interventions in Landscape: Projects/Documentation/Film/Video," Hayden Gallery, Massachusetts Institute of Technology, Cambridge
 Institute of Contemporary Art, Boston, Massachusetts
1976 "Rooms P.S. 1," Institute for Art and Urban Resources, P.S. 1, Long Island City, New York
 "New York-Downtown Manhattan: Soho," Berlin Festival, Akademie der Kunst, Berlin, West Germany
 "Four Artists," Williams College Museum of Art, Williamstown, Massachusetts
 "Drawing/Transparency," Cannaviello Studio d' Arte, Piazza de Massimi, Rome, Italy
1977 "Drawings for Outdoor Sculpture: 1946-1977," John Weber Gallery, New York City
 "Site Sculpture," Zabriskie Gallery, New York City
 "Contact: Women and Nature," Greenwich Library, Greenwich, Connecticut
 "Nine Artists: Theodoron Awards," Solomon R. Guggenheim Museum, New York City
 "Women in Architecture," Brooklyn Museum of Art, Brooklyn, New York
1978 "Inaugural Exhibition," Max Protetch Gallery, New York City
 "Architectural Analogues," Downtown Branch Museum, Whitney Museum of American Art, New York City
1979 "Drawings by Sculptors," Touchstone Gallery, New York City
 "Art and Architecture, Space and Structure," Protetch-McIntosh Gallery, Washington, DC
 "The Minimal Tradition," Aldrich Museum of Contemporary Art, Ridgefield, Connecticut
 "Spring Loan Exhibition," Weatherspoon Art Gallery, University of North Carolina, Greensboro

Selected Bibliography

1970 "1970 Annual Exhibition: Contemporary American Sculpture," Whitney Museum of American Art, New York City (catalogue)
1971 Wellish, Marjorie, "Material Extensions in New Sculptures," ARTS MAGAZINE, vol 45, #8, Summer, pp. 24-26
1972 Alloway, Lawrence, "Art," THE NATION, vol 214, #13, March 27, pp. 413-414
1973 Anderson, Laurie, "Mary Miss," ARTFORUM, vol 12, #3, November, pp. 64-65
1974 Lippard, Lucy, "Mary Miss: An Extremely Clear Situation," ART IN AMERICA, vol 62, #2, March/April, pp. 76-77
1975 Heinemann, Susan, "Reviews," ARTFORUM, vol 13, #7, March, pp. 60-61
 Morris, Robert, "Aligned with Nazca," ARTFORUM, vol 14, #2, October, pp. 26-39
 Ratcliff, Carter, "New York Letter," ART INTERNATIONAL, vol 19, #10, December, pp. 42-44
1976 Baracks, Barbara, "Artpark: The New Esthetic Playground," ARTFORUM, vol 15, #3, November, pp. 32-33
 Frank, Peter, "Reviews," ARTnews, vol 75, #1, January, p. 122
1977 Rosen, Nancy, "A Sense of Place: Five American Artists," STUDIO INTERNATIONAL, vol 193, #986, March/April, pp. 119-120
1978 Alloway, Lawrence, "Reviews," THE NATION, vol 227, #12, October 14, pp. 389-390
 Kingsley, April, "Six Women at Work in the Landscape," ARTS MAGAZINE, vol 52, #8, April, pp. 110-111
 Onorato, Ronald J., "Illusive Spaces: The Art of Mary Miss," ARTFORUM, vol 17, #4, December, pp. 28-33
 Perreault, John, "Reviews," THE SOHO WEEKLY NEWS, vol 6, #2, October 12, p. 35
1979 Foote, Nancy, "Monument-Sculpture-Earthwork," ARTFORUM, vol 18, #2, October, pp. 32-37
 Pincus-Witten, Robert, "Entries: Cutting Edges," ARTS MAGAZINE, vol 53, #10, June, pp. 105-109
 Stevens, Mark, "Three for the Eighties," NEWSWEEK, vol 93, #13, March 26, p. 92

Born in New York City, 1945
Lives in Wilmington, Vermont

Individual Exhibitions

1975 Sperone Westwater Fischer,
New York City
1976 Wadsworth Atheneum,
Hartford, Connecticut
1977 Smith College Museum of
Art, Northhampton,
Massachusetts
Art Museum of South Texas,
Corpus Christi
Neuberger Museum, State
University of New York,
Purchase
Greenburgh Nature Center,
Scarsdale, New York
1978 Sperone Westwater Fischer,
New York City
1979 Portland Center for the
Visual Arts, Oregon
School of Visual Arts, New
York City

Selected Outdoor Installations

1972 Pelham Bay Park, City Island,
New York City
1973 Saratoga Center for the
Performing Arts, Saratoga,
New York
Heckscher State Park, Long
Island, New York
1975 Everglades National Park,
Homestead, Florida
1976 Chesapeake Bay Center for
Environmental Studies,
Smithsonian Institution,
Edgewater, Maryland

Selected Group Exhibitions

1969 Art Resources Center
Gallery, Whitney Museum
of American Art, New York
City
1970 "Light and Environment,"
Hudson River Museum,
Yonkers, New York
1971 "Ten Young Artists—
Theodoron Award Show,"
Solomon R. Guggenheim
Museum, New York City
1975 "Recent American Art,"
Solomon R. Guggenheim
Museum, New York City
1976 "Ideas on Paper," The
Renaissance Society,
University of Chicago,
Illinois
"Nine Sculptors: On the
Ground, In the Water, Off
the Wall," Nassau County
Museum of Fine Arts,
Roslyn, New York
"Drawing Today in New
York," Sewall Gallery, Rice
University, Houston, Texas
(traveling exhibition)
1977 "Documenta 6," Kassel,
West Germany

"Artists in Residence 1975,
1976, 1977," Bear
Mountain Inn, Bear
Mountain, New York
1978 "Carl Andre, Dan Flavin,
Donald Judd, Richard
Long, Brenda Miller,
Michael Singer," Hurlbutt
Gallery, Greenwich,
Connecticut
"Drawings and Other Works
on Paper," Sperone
Westwater Fischer, New
York City
1979 "Drawings by Sculptors,"
Touchstone Gallery, New
York City
"1979 Biennial Exhibition,"
Whitney Museum of
American Art, New York
City
"Eight Sculptors,"
Albright-Knox Art Gallery,
Buffalo, New York

Selected Bibliography

1971 Waldman, Diane, "Ten
Young Artists: Theodoron
Awards," Solomon R.
Guggenheim Museum,
New York City (catalogue)
1975 Russell, John, "Michael
Singer Blends Nature with
Art . . .," THE NEW YORK
TIMES, vol 525,
December 27, p. 11
1976 Collins, Tara, "Michael
Singer," ARTS MAGAZINE,
vol 50, #6, February, p. 11
Foote, Nancy, "Reviews,
New York," ARTFORUM,
vol 14, #7, March, p. 70
Gussow, Alan, "Let's Put the
Land in Landscapes," THE
NEW YORK TIMES, vol 525,
March 14, p. D1
Kuspit, Donald B., "Review of
Exhibitions: New York,"
ART IN AMERICA, vol 64,
#4, July/August,
pp. 104-105
Ratcliff, Carter, "Reviews:
New York," ARTFORUM,
vol 15, #2, October, p. 63
Zucker, Barbara, "New York
Reviews," ARTnews,
vol 75, #2, February,
pp. 110-112
1977 Baker, Elizabeth C., "Report
From Kassel, Documenta
VI," ART IN AMERICA,
vol 65, #5, September/
October, p. 44
Linker, Kate, "Michael
Singer: A Position In, And
On, Nature," ARTS
MAGAZINE, vol 52, #3,
November, pp. 102-104

Siegel, Jeanne, "Notes on
the State of Outdoor
Sculpture at Documenta
6," ARTS MAGAZINE,
vol 52, #3, November,
p. 132
1978 Bee, Maeve, "The Gallery
Connection," OCULAR,
vol 3, #3, Fall, p. 60
Forgey, Benjamin, "Art Out of
Nature . . .,"
SMITHSONIAN, vol 8, #10,
January, pp. 62-69
Russell, John, "Michael
Singer," THE NEW YORK
TIMES, vol 527,
November 17, p. C19
Stevens, Mark, "Browser's
Delights," NEWSWEEK,
vol 92, #20, November 13,
p. 105
1979 Beatty, Frances, "Whitney
Winter Biennial,"
ART/WORLD, vol 3, #6,
February/March, p. 1
Hughes, Robert, "Roundup
at the Whitney Corral,"
TIME, vol 113, #9,
February 26, pp. 72-73
Saunders, Wade, "Art, Inc.:
The Whitney's 1979
Biennial," ART IN
AMERICA, vol 67, #3,
May/June, p. 99
Shapiro, Lindsay, "Reviews,"
CRAFT HORIZONS, vol 39,
#1, February, p. 51
Whelan, Richard,
"Discerning Trends at the
Whitney," ARTnews,
vol 78, #4, April, pp. 86-87

Michael Singer